FRAGONARD

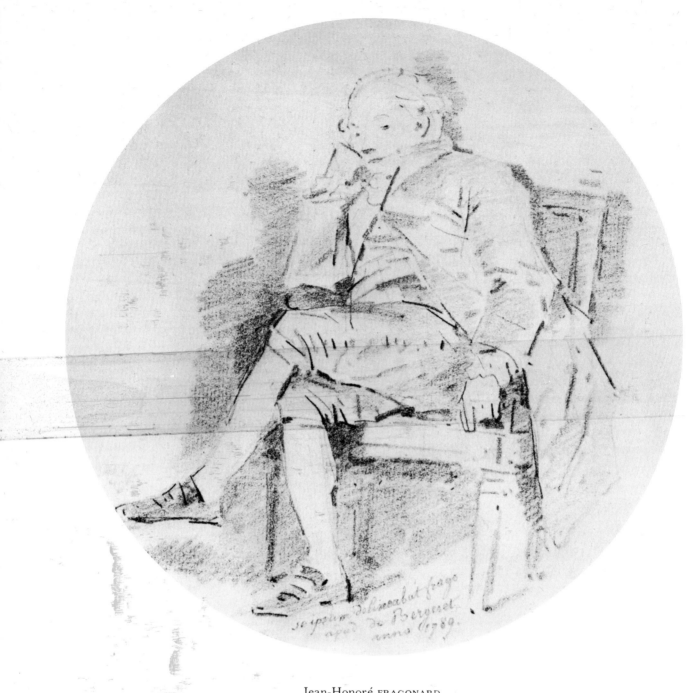

Jean-Honoré FRAGONARD
Self-portrait
PARIS, Fondation Custodia (F. Lugt collection), Institut Néerlandais. Roundel in black chalk
17·5 cm. Annotated by Fragonard: se ipsum delineabat frago/apud de Bergeret/anno 1789.

FRAGONARD

DAVID WAKEFIELD

ORESKO BOOKS LTD·LONDON

ACKNOWLEDGEMENTS

I would like to express my gratitude to the following people who have helped me in various ways: Dr. Anita Brookner of the Courtauld Institute, who first awakened my interest in the French eighteenth century; Professor Francis Haskell of Oxford University for generously allowing me to make use of some of his ideas, particularly the substance of a lecture given to the Taylor Institution, Oxford, in 1975; Professor Jean Seznec of All Souls College, Oxford, for his constant willingness to answer my queries; the staff of the Witt Library; and Christopher Wright for help of many different kinds, but above all for his constant enthusiasm and interest in this project.

I would also like to thank all the following for their help in providing photographs: Banque de France, Paris; Bowes Museum, Barnard Castle; British Museum, London; Calouste Gulbenkian Foundation, Lisbon; Dr. Emile Bührle, Zürich; Cailleux Collection, Paris; Detroit Institute of Arts, Detroit; Ecole des Beaux-Arts, Paris; Frick Collection, New York; Fitzwilliam Museum, Cambridge; Mrs. Fowler Mc-Cormick, Chicago; Hermitage, Leningrad; Institut Néerlandais, Paris; Los Angeles County Museum of Art, Los Angeles; Metropolitan Museum of Art, New York; Museum of Art, São Paulo; Musée des Beaux-Arts, Besançon; Musée des Beaux-Arts, Rouen; Musée des Beaux-Arts, Tours; Musée Cognacq-Jay, Paris; Musée Fragonard, Grasse; Musée du Louvre, Paris; Museum of Modern Art, Barcelona; Musée de Picardie, Amiens; National Galleries of Scotland; National Gallery of Art, Washington; The Rosenbach Foundation, Philadelphia; Sterling and Francine Clark Art Institute, Williamstown; Stichting Collectie Thyssen-Bornemisza, Amsterdam; Toledo Museum of Art, Toledo, Ohio; M. Arthur Veil-Picard, Paris; Wallace Collection, London; Worcester Art Museum, Worcester, Massachusetts; Photographie Bulloz; Photographie Giraudon; Service de Documentation Photographique de la Réunion des Musées Nationaux; John R. Freeman & Co. Ltd.; and Mrs. Sabine McCormack and Ms. Peggy Edwards of Phaidon Press.

First published in Great Britain by
Oresko Books Ltd., 30 Notting Hill Gate, London W11

ISBN 0 905368 01 0 (cloth)
ISBN 0 905368 05 3 (paper)
Copyright © Oresko Books Ltd. 1976

Printed in Great Britain by
Burgess and Son (Abingdon) Ltd., Abingdon, Oxfordshire

Jean-Honoré Fragonard

THE GONCOURT BROTHERS, whose *L'Art du dix-huitième siècle* must still rank as the best general account of French eighteenth-century art, began their 1865 study of Fragonard with the statement that, after Watteau, he was the only true poet of his time. They went on to define Fragonard as 'the uninhibited raconteur, the gallant amoroso, pagan, playful, with Gallic malice, an almost Italian temperament and a French mind'. This lyrical, poetic strain which the Goncourts perceptively divined in Fragonard, despite their incomplete knowledge of his work, seems to have escaped many commentators, and to this day, in English-speaking countries at any rate, he remains one of the least known and least understood French artists. To the layman his name is familiar only as the author of erotic subjects, nubile young girls and their impatient lovers, all with an obvious appeal. This was the aspect of Fragonard which made him popular and successful in his own day with the rich financiers, actresses and demi-mondaines, who probably saw in him no more than a very accomplished pornographer, good enough for dashing off a spicy scene for their private apartments and for the amusement of their friends. In fact, erotic subjects count for only a fairly small part of Fragonard's total output, and it is doubtful whether they are his best and most original paintings.

Even today Fragonard has retained this aura of the connoisseur's painter, frivolous, light-hearted, technically brilliant but essentially vacuous, in short, typical of the decadent art of the Ancien Régime which earned the well-deserved strictures of Rousseau, Diderot and later Romantic critics. It is hoped that this study will show this view of the painter to be both misleading and incomplete. Like all prolific artists Fragonard can sometimes be trivial and banal, but at his best he is a great artist and deserves to rank with Watteau or Tiepolo, the master of a range of subject and mood unrivalled in eighteenth-century France. He possessed not only technical virtuosity, but also a powerful creative imagination which frequently bordered on the epic and fantastic, linking him retrospectively with the names of Tasso and Ariosto. The extraordinary vitality and sometimes visionary quality of his work carry us far beyond the confines of the Rococo world he is supposed to incarnate.

Jean-Honoré Fragonard was born in Grasse near Aix-en-Provence on 5 April 1732. He was the son of a glove maker who speculated his entire fortune in a disastrous enterprise, probably in fire engines, and in 1738 came to Paris to try to retrieve his capital outlay. This Provençal background, with its strong light, vivid colours, cypress trees and olive-groves, evoked in rhapsodic terms by the Goncourt brothers in their essay, left an indelible stamp on Fragonard's mind, for he remains always, unmistakably, a Mediterranean artist. The importance of milieu, however, should not be exaggerated, for Fragonard later showed that he was equally sensitive to the northern Dutch landscape, and this Protean adaptability and readiness to take advantage of any new opportunity is in itself typical of the easy-going southern temperament. Fragonard is one of the least consistent of all artists. In Paris, where he followed his parents, he was first apprenticed as a clerk to a notary, who, spotting the boy's aptitude for drawing, urged Fragonard's mother to send him to a painter's studio. In 1747 the boy began his studies under Boucher, Mme. de Pompadour's chief protégé, then at the height of his fame. Boucher, however, had no time for a completely untrained pupil and sent him on to Chardin. Fragonard was no more successful under Chardin, and after about six months the master made it clear to his pupil that he was not satisfied with his progress. We can well imagine that Chardin's advice, 'You seek, you scrape, you rub, you glaze, and when you have got hold of something that pleases, the whole picture is finished', and his laborious teaching methods based on copying prints were much too slow for someone of Fragonard's impetuous temper. Meanwhile, in his spare time, Fragonard copied the paintings he saw in the Paris churches and private collections. It was perhaps on the strength of these copies that around 1748 Boucher decided to take Fragonard back into his studio, where he spent the next four years.

Boucher's influence is predominant in Fragonard's early works like the *Woman Gathering Grapes* (Plate 1), *The See-saw* (Plate 4) and *Blind Man's Buff* (Plate 3), with their light tonality of grey-blue, green and pink and with the contrived disorder of their setting, what the Goncourts called 'le fouillis' and what Marie Antoinette created in real life at the Petit Hameau at

Versailles. Fragonard never entirely abandoned Boucher's preference for the light palette, but he far exceeded his master in imaginative power when he later transformed Boucher's anodyne pastorals into such overwhelming creations as *The Fête at Saint-Cloud* and *The Fête at Rambouillet*. For Boucher nature was merely a picturesque backdrop in which plants and shrubs could be shifted at will like theatrical props. Theatre and painting, in fact, were closely linked throughout the eighteenth century, and Boucher frequently designed scenery for such heroic pastorals as *Issé*, by Destouches and Lamothe. Critics saw him as the natural heir to the tradition of the gallant eclogue, stretching from Virgil to Fontenelle, but after the middle of the century the public began to tire of the false gentility of Boucher's marquises dressed up as shepherdesses and looked for something more authentically rustic and with stronger human feeling. The difference between Boucher and Fragonard can be measured if we compare their respective treatment of two subjects from Tasso, Boucher's *Sylvia and the Wolf* (fig. 1) of 1756, painted for the Hôtel de Toulouse, with Fragonard's slightly later *Rinaldo in the Gardens of Armida* (c. 1765) (Plate 13). Boucher's picture is pretty and charming, but passive, totally undramatic, whereas Fragonard's is all violent movement, the hero in his plumed helmet dashes on the scene, Armida sweeps down to greet him, and the trees and clouds are caught up in a vortex of colour. Between 1750 and 1765 Fragonard transformed Boucher's technique out of recognition, and it is ironic that Boucher's parting advice to Fragonard, on the departure of the younger man from his studio, was not to take the Old Masters seriously.

In 1752 Boucher urged Fragonard to compete for the Prix de Rome, even though he had received no formal academic training. He submitted for the competition *Jeroboam Sacrificing to the Golden Calf* (Plate 5), a competent work in the required historical style which he mastered with surprising ease and promptly won the prize. Before going on to Rome Fragonard had to spend four years at the Ecole Royale des Elèves Protégés, an academic school installed in the courtyard of the Louvre, under the directorship of Carle Van Loo. The curriculum consisted of drawing from life and from statues, reading from Bossuet and the classical authors and making copies after Old Masters from Paris private collections and neighbouring châteaux. In 1756 Fragonard went on to the Ecole de Rome, the mecca of any aspiring young artist in the eighteenth century, and it was probably there, in 1757, that he met the young Greuze. The director at that time was the popular and easy-going Natoire, who kept up a regular correspondence with the marquis de Marigny, Directeur des Bâtiments in Paris and the brother of Mme. de Pompadour. These letters give us an idea of Fragonard's activities in Rome, where, despite the climate of tolerant

fig. 1 François BOUCHER
Sylvia and the Wolf
Oil on canvas 122·5 × 133 cm. 1756. Tours, Musée des Beaux-Arts

One of a series of four oval overdoors illustrating Tasso's poem *Aminta*, painted for the duc de Penthièvre's Paris town house, the Hôtel de Toulouse, now the Banque de France. Two of the paintings are still there, the other two are in the Musée des Beaux-Arts, Tours.

paternalism, he does not seem to have been entirely happy. At that time there was a growing conflict between academic teaching and the new, fashionable ideas favouring freedom and spontaneity; Fragonard was caught in the cross-fire. Nor were the authorities themselves in agreement about the best training for an artist. Marigny seems to have insisted on strict, regular copying from Antiquity and the Old Masters, while Natoire was more inclined 'to allow genius a little freedom' (30 August 1758), fearing that 'the imitation of certain masters may do him harm' (31 August 1758). In October, we learn, Fragonard was making progress on a copy after Pietro da Cortona's *St. Paul Recovering his Sight* in the Capuchin Church, but he was never entirely at ease with the austere High Renaissance and Baroque paintings he saw in Rome. Natoire was perceptive enough to see where his pupil's real bent lay. 'Fragonard, with his gifts, has an astounding facility to change his ways from one moment to the next, and this makes his work uneven' (30 August 1758). The one word which crops up most often in these letters in reference to Fragonard is 'feu', an ardent, spontaneous temperament which his mentors wished to encourage but, with their routine habits and half-hearted praise of his work, did their best to quench. We are reminded of Stendhal's comment in chapter LXVI of his *Histoire de la peinture en Italie* that 'Les règles boiteuses ne peuvent

fig. 2 Richard de SAINT-NON
Illustration from 'Fragments des peintures et tableaux les plus intéressants des palais et églises d'Italie' after Saint-Non's own pen and ink sketch from 'Peinture antique d'Herculanum'
Etching 13·8 × 19·8 cm.

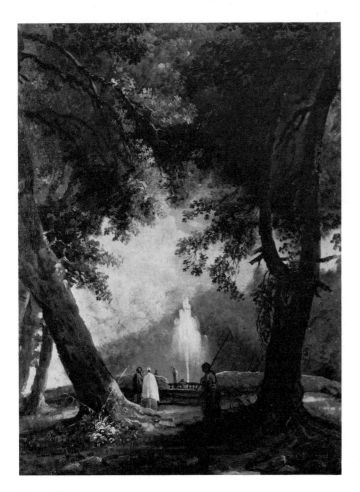

fig. 3 Hubert ROBERT
Villa Conti at Frascati
Oil on canvas 62 × 47 cm. Besançon, Musée des Beaux-Arts

Probably executed in or around 1760 during Robert's stay with Fragonard and Saint-Non in Rome and the neighbouring countryside. This painting shows how close Robert and Fragonard were, except that Robert's style was rather more detailed and meticulous.

suivre l'élan du génie'. 'Lame rules cannot keep up with the impetus of genius.'

In November 1759 Fragonard was fortunately rescued from this state of disorientation by the timely appearance in Rome of the abbé de Saint-Non. Richard de Saint-Non (1727–1791) was typical of the eighteenth-century amateur artist and patron. As abbé commendataire of Pothières, near Langres, he possessed a handsome ecclesiastical sinecure worth 8000 francs a year income, which allowed him to devote himself to the arts. He was a reasonably skilled draftsman, a good etcher (fig. 2), later etching many of Fragonard's own drawings, and travelled widely in England and Holland, making engravings after Rembrandt. Saint-Non deserves to be remembered above all for his generous support of young artists, especially Fragonard, for whom he performed the same service which the Abbé Gougenot had for Greuze, enabling him to travel and complete his artistic education. His assistance was especially good for Fragonard because he had none of that academic pedantry and exaggerated respect for classical Antiquity of Caylus and Winckelmann. Like the président de Brosses he belonged more to the generation of the 'picturesque' traveller, interested in Italy for its way of life more than its monuments, an observer with a sharp eye for detail and the happy accident. The abbé arrived in Italy with another protégé, the young painter Taraval, and presumably met Fragonard early in 1760. It was probably through Saint-Non that, about this time, Fragonard met Hubert Robert. The two artists became inseparable friends, and their paintings of the Italian countryside are sometimes so close as to be indistinguishable from each other (fig. 3). Hubert Robert, of a comfortably off middle-class family, had all the advantages which Fragonard lacked, a sound classical education and knowledge of literature. It was very likely that in contact with Robert and Saint-Non, Fragonard became familiar with the great Italian poets, Tasso and Ariosto, whose works he so brilliantly illustrated (Plates 39a–f). We can imagine the three friends reading passages from Ariosto's *Orlando Furioso* together, and although Fragonard was not bookish he showed a rapid, intuitive understanding of the poem's meaning.

In March 1760 Natoire gave Fragonard leave of absence to travel with Saint-Non to Venice, making several stops en route. Their first port of call was Tivoli, where the Duke of Modena put the Villa d'Este at their disposal. There they spent the summer of 1760, joined by Robert, talking and sketching from morning to dusk in the decaying splendour of the park with its avenues of cypresses, its fountains and statues overshadowed by the massive façade of the villa. This was a decisive moment in Fragonard's career, for at last he could forget the vexations of academic teaching and give free rein to his own inclinations. The result was that rapid,

sketchy and yet comprehensive vision of nature in *The Giant Cypresses at Tivoli*, *The Entrance to Fontanone* and the *View of the Coast near Genoa* (Plates 8, 9 and 10). It was at Tivoli that he learned to draw the huge trees and their overhanging boughs which dominate the later Parisian park scenes. If these seem exaggerated to modern observers it should be remembered that in the eighteenth century the gardens of the Villa d'Este, and most other Italian gardens, were in a state of considerable neglect; overgrown trees and toppling statues were not simply the product of a lyrical imagination. The président de Brosses, writing in 1737–40, reported that the whole place was already decayed. 'The Duke of Modena neglects it totally; the gardens, arbours, woods, the sloping and terraced flowerbeds have all gone to seed and lie fallow' (*Lettres familières écrites d'Italie*).

After this idyllic sojourn at Tivoli the party presumably went on to Venice. Although there is no actual record of a visit, it seems inconceivable that Fragonard had not seen at first hand frescoes by Giovanni Battista Tiepolo, his closest counterpart among contemporary painters. In March 1761 he set off alone, at Saint-Non's expense, for Naples, where he was most deeply impressed by the works of Solimena and Luca Giordano, both *fa presto* artists with whom he felt a closer affinity than with the High Renaissance painters. Meanwhile Natoire seems to have been reconciled to his pupil's new-found freedom and wrote to Marigny promising that 'The Abbé [Saint-Non] will bring back with him a number of the young artist's charming sketches'. This refers, we may suppose, to Fragonard's drawings of Tivoli. During this period Fragonard had acquired a much greater ease with the Old Masters, as we can see from the wonderful pen and ink sketches after works in Bologna, Rome and Naples incorporated into Saint-Non's illustrated volume, *Fragments des peintures et tableaux les plus intéressants des palais et églises d'Italie* (1770–73). This work consists of ninety pieces, engraved aquatints by Saint-Non from drawings by Robert, Fragonard and Saint-Non himself. The abbé's other large volume, the *Voyage de Naples et de la Sicile* (1781–86), also included etchings after Fragonard's drawings, but much of the descriptive text is not by Saint-Non, who never travelled as far as Sicily, but by Vivant Denon. This vast and costly enterprise, originally designed to cover the whole of Italy, had to appear in truncated form and was to be the ruin of Saint-Non, whose financial position was not improved by the suppression of his abbey by the Revolutionary government in 1791. As an admirer of Rousseau and Voltaire, Saint-Non, however, shared the Encyclopédistes's radical sympathies. He quickly reconciled himself to the new situation and does not seem to have shed many tears over the passing of the Ancien Régime. The best testimony to his intuitive understanding of Fragonard are the words he wrote to his brother, M. de la Bretèche. 'M. Fragonard is all ardour; his drawings are so numerous that one cannot wait for the next; they delight me. I find a kind of magic in them.'

Fragonard returned to Paris with Saint-Non in September 1761. The next four years of his life are sparsely documented, but he must have spent a good deal of this time preparing for his début as a history painter with the exhibition of *Coresus Sacrificing Himself* in 1765. It must also have been shortly after Fragonard's return from Rome, between 1762 and 1765, with the vision of Tivoli fresh in his memory and armed with numerous sketches, that he painted the group of Italianate landscapes including *The Washerwomen* (Plate I), *The Gardens of the Villa d'Este* (Plate 12) and *The Waterfall at Tivoli* (Plate 11). All of these are minor masterpieces, quiet, restrained, with a remarkable density of texture, and rigorous in composition. The use of thick chalky white paint in *The Washerwomen* serves to emphasize the stiffness of linen hanging out to dry. Fragonard's feeling for surface texture was as unerring as Chardin's. The symmetry of these paintings, for example *The Gardens of the Villa d'Este* with its carefully balanced statues and terraces, was given by the subject, but they make an interesting contrast to such non-Italianate landscapes as the slightly earlier *Storm* (Plate 6), of about 1759, and the *Annette and Lubin* (Plate 7), dating from soon after 1762. In both of these the mass of the composition is heaped up to the left of centre. In *The Storm* this creates a tumultuous, dramatic effect heightened by the dark clouds on the right, while in the pastoral *Annette* the brown hillock contrasts with the airy blue spaciousness of the distance. Fragonard was not merely a factual observer of nature; he also portrayed the full range of its moods. In the group of 'Dutch' landscapes, for instance, the *Autumnal Landscape* at Amiens, the scene at Grasse (Plate 20) and, the most poignant of all, *The Three Trees* (Plate 19), this can be as desolate and melancholy as in any by Ruysdael. Here nothing could be more remote from the Provençal *joie de vivre* which Fragonard is supposed to typify. This raises the problems of Fragonard's possible visit to Holland. If he went there at all, and there is no evidence that he did, it may have been during the years 1761–65, although M. Ananoff suggests that it was a decade later, in 1772–73. The hypothesis of a Dutch visit rests solely on visual affinities with Rembrandt, but these could be explained from Fragonard's knowledge of works in French collections. Saint-Non had also made a number of etchings after Rembrandt which Fragonard would have known.

Official recognition and fame came for Fragonard in March 1765, when he submitted *Coresus Sacrificing Himself* (Plate 17) as his 'morceau de réception' to the Academy and was received as a full member of that body, the highest honour to which an eighteenth-century artist could aspire. What is remarkable is that when this

highly dramatic work was exhibited at the Salon of the same year it managed to satisfy both the jury and the critics, whose views were usually diametrically opposed. Diderot was so excited by the painting that he allowed his fertile imagination to re-create it in the form of a dream ('Plato's Cave'), in which he multiplied the number of victims and laid so much stress on the macabre element ('l'effroi') of the work that he nearly transformed it into a Gothic horror novel. Diderot was perhaps guilty of only slight exaggeration, for there is something unmistakably nineteenth century in the Furies swooping down on the left, almost anticipating Prudhon's *Justice and Vengeance Pursuing Crime*, or in the figure of the young priest to the left of Callirhoe, with his tablet on his knees, who has the same expression of inspired zeal as Ariosto in the later drawing (Plate 39a). Whatever latent Romantic tendencies the art historian may discover in Fragonard, they were, of course, unconscious on the painter's part. In the context of its own time, Fragonard's work marked a notable and successful attempt to reconcile the two conflicting tendencies which divided French eighteenth-century art, the Poussiniste demand for a competent and dramatic treatment of the set theme and the Rubéniste love of colour and variety for its own sake.

Fragonard, however, seems to have been dissatisfied with his own success. Although Cochin persuaded Marigny to have the *Coresus* reproduced by the Gobelins tapestry works, payments from the royal treasury were notoriously slow and ungenerous. The inadequate financial reward accorded to the honour of history painting, coupled with the feeling that this kind of work went against his natural inclinations, persuaded Fragonard to turn to a different clientèle, the rich financiers, aristocratic amateurs and courtesans with bottomless pockets and easily satisfied tastes. They were not the sort of people to take much notice of the new fashion among intellectuals for Antiquity and morally elevating subjects. From now on M. de Varanchan, the marquis de Véri, Randon de Boisset, Sophie Guimard and, later, Bergeret de Grancourt, provided Fragonard with a steady stream of commissions for erotic nudes, cupids, unmade beds, lively haystack scenes and similar subjects, all dashed off in a few rapid strokes of the brush. They gave him a quick source of income at the cost of no great mental exertion. Some of these, like *The Longed-for Moment* (Plate 30), *The Stolen Shirt* (Plate 31), or, most suggestive of all, *The Bed with Cupids* (Plate 33) are deservedly famous specimens of erotic art, what the Goncourts called 'the divine poem of Desire'. They are also strangely de-personalized creations. Fragonard's lovers have no individual identity, and their faces consist only of slot-like eyes and pink cheeks. Sexuality for him was simply violent movement, a manifestation of the universal 'élan vital', without any of the psychological undertones of Watteau and equally differ-ent from the langorous passivity of Boucher's love scenes. It could sometimes stop at mere titillation, as in *The Swing* (Plate II), painted for the baron de Saint-Julien, who is seen lolling in the foliage on the left enjoying a good view of his young mistress's legs. To an unsympathetic observer this painting might easily be held up as an example of the frivolous, licentious way of life of the upper classes in the Ancien Régime. Love is reduced to idle gallantry, and marriage is derided, for the husband is giving a helping hand to the swing. The girl is a doll-like coquette dressed up in flounces and billows, while the statue of Cupid archly puts his finger to his lips; and yet there is a peculiar intensity in the expression of the baron's face which reminds us that the age of 'sensibilité' had already dawned. This little episode is somehow engulfed by a luxuriant hot-house growth of vegetation, reminiscent of Zola's Le Paradou in *La Faute de l'Abbé Mouret*, another erotic fantasy world created by the Provençal imagination.

Meanwhile C. N. Cochin, the artist and critic, continued to exert his influence in Fragonard's favour and in 1766 got for him the important commission to paint the allegorical figures of *Day* and *Night* for the royal Château de Bellevue. Cochin by that time was firmly established as artistic mentor to Marigny, who, as Directeur des Bâtiments from 1754, was responsible for royal patronage, a position of considerable power. In 1749 Cochin had accompanied the young Marigny, when still M. de Vandières, on an educational tour of Italy during which he succeeded in weaning his pupil from a preference for the 'petite manière', the Rococo mode of Boucher and Van Loo, in favour of the grand style. Cochin was no doctrinaire, however. He was among the earliest French critics to state the heretical view that Raphael was perhaps not the greatest painter ever to have lived and was also a pioneering champion of Veronese and the colourist Venetian school. In 1749 he wrote prophetically that 'The true charm of nature which consists in colour, harmony and the overall concordance of the picture has yet to be discovered'. Elsewhere, when he wrote of 'nature in its infinite variety', he seems to make a direct appeal for an artist like Fragonard to translate his wishes into reality. In December 1766 he wrote to Marigny suggesting a competition designed to discredit Boucher, Pierre and Vien and to throw his favourites, notably Fragonard, into prominence. There is no record of the outcome of this scheme.

In the following year, 1767, Fragonard exhibited several works at the Salon, among them *Groups of Putti in the Sky*, the *Head of an Old Man* and a number of drawings. This time, however, he failed to win the critics's approval. Diderot, who devoted his longest and most inspired commentary to this Salon, scornfully dismissed the *Putti* as a 'fine, soft, yellow, well-browned omelette'. He clearly suspected Fragonard of deserting

the grand manner which he had seemed to inaugurate with the *Coresus* in 1765 and of returning to Rococo mannerism: 'M. Fragonard, when a man has made a name for himself, he should have a little more self-respect'. Bachaumont similarly accused him of back-sliding into the 'luxuries of Capua'. In these and other criticisms there is the strong implication that private patronage had been a bad moral influence on Fragonard, and that instead of painting 'bambochades' for rich financiers, he ought to have been devoting his energies to the revival of history painting, which the state was doing its best to promote. The critics's disappointment was confirmed by Fragonard's failure to exhibit at the following Salon of 1769, when the newspapers began to report that 'the lure of profit and the interest in boudoirs and wardrobes have diverted the painter from striving after glory'.

By this time Fragonard had reached his maturity. It was in or around 1769 that he painted some of his most idiosyncratic works, the celebrated 'fancy portraits' (Plates III and 25–29) which must rank among the most extraordinary virtuoso pieces in French art. Two of them, we learn from Fragonard's own inscriptions, were painted in only one hour; more than anything else they have created his reputation as a *fa presto* artist. The painted surface is reduced to long shreds of colour which seem to perform arbitrary arabesques at the caprice of the artist. Whereas most French portraiture is usually sober and restrained, these are unashamedly extravagant, almost Spanish in their self-confident assertiveness. They seem to thrust themselves forward at the spectator, like *The Warrior* (Plate 27) with his reckless contempt, a proud isolated individual framed only by a stone balcony and set against a bare back-ground. This is an essentially aristocratic art (two of the sitters are members of the Harcourt family) in keeping with the mood of one of Fragonard's favourite books, *Don Quixote*. It is no accident that the abbé de Saint-Non is shown in the guise of Cervantes's hero (Plate 29). While some of the sitters can be identified, for example Diderot, Sophie Guimard and Saint-Non, not all are clear. Who, for instance, is the mysterious *Warrior*, with his proud, angular jaw, embittered expression and clenched fist, seeming to defy the world like some tragi-comic hero?

On 17 June 1769, after thirty-seven years of the care-free bachelor's life, Fragonard married his pupil Marie-Anne Gérard, the elder and less attractive of two sisters from Provence. The younger sister, Marguerite Gérard (Plate 45) came to live with the couple in 1775 and, although barely literate, she was a highly intelligent woman and a talented artist in her own right (fig. 4), collaborating in many of Fragonard's late works. An extensive correspondence between her and Fragonard survives, quoted extensively by Portalis, which suggests that, if she did not actually become his mistress, the

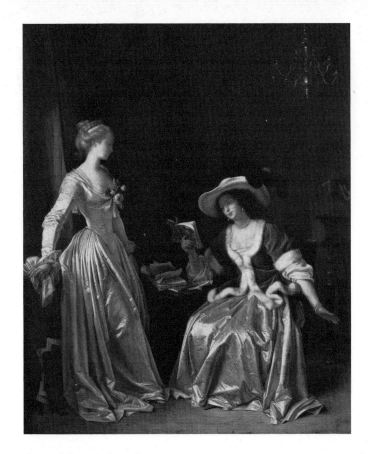

fig. 4 Marguerite GÉRARD
The Reader
Oil on canvas 65 × 54 cm. Cambridge, Fitzwilliam Museum

The standing woman is wearing a cream satin dress, the seated woman a red jacket with white fur. The background is buff grey, with dark green curtains and table cloth. The figure of the standing woman bears a close resemblance to the girl in Fragonard's *Stolen Kiss* in the Hermitage, which may also be partly by the hand of his former pupil, Mlle. Gérard. *The Reader* was bequeathed to the Fitzwilliam Museum by Charles Brinsley Marlay in 1912.

painter may later have regretted his choice of wife. Biographers have made a good deal of the influence of marriage on Fragonard's art. It is true that after this he painted a considerable number of scenes of happy families and children at school like *The Cradle* (Plate 50), *The Schoolmistress* (Plate 51) in the Wallace Collection and many others, which certainly reflect his own domestic contentment and delight in children. Fragonard was, however, a canny enough opportunist to realize that by 1770 the moral tide had already turned against licentious subjects, even though he continued to turn them out when the occasion demanded. Diderot had acclaimed Greuze as his ideal painter of the simple moral virtues; the whole of the literate French public was reading the novels of Richardson and, in the theatre, the serious-minded *drame bourgeois* had ousted the pastorals of Favart and Lamothe. It may well be, then, that Fragonard's new interest in domestic subjects

was an attempt to rival Greuze on his own ground and to exploit an increasingly popular vein. It is very likely that the subject of *The Cradle*, and other paintings based on the theme of the happy family, is taken from a now forgotten novel *Miss Sara Th . . .* (1765) by J. F. de Saint-Lambert, a tale of a rich, well-born young woman who voluntarily abdicates her social position by marrying a farmer for love. They lead a model life of conjugal felicity, beget five children and maintain a simple, orderly household in which the servants are treated as equals.

Meanwhile, despite the disapprobation of the critics and the change in the moral climate, Fragonard continued to be the most sought-after artist for the decoration of Parisian drawings rooms. It was probably in 1770 that he was commissioned to paint the panels for Mlle. Guimard's house, built by Ledoux, on the Chaussée d'Antin. Sophie Guimard (1743–1816) was the most famous ballet dancer of her time. Bachaumont described her as being 'as light as Terpsichore' (May 1762), and her slender, willowy form is admirably caught in Fragonard's portrait (Plate 28). When Fragonard knew her around 1770 she was kept in the height of luxury by the prince de Soubise. Everything she did and touched set the fashion in Parisian society and filled the gossip columns of the newspapers. She gave three dinner parties a week, one for grands seigneurs and members of the court, another for artists and writers; the third was simply an orgy where, in Bachaumont's words, 'debauchery and vice were carried to the extreme'. Her reputation for elegance and luxury spiced with scandal, which earned her Marmontel's epithet 'la belle damnée', made Fragonard the obvious choice of painter for the decoration of her hôtel. She installed her own private theatre, with a ceiling by Taraval, in the house, opened on 8 December 1772. Fragonard must presumably have worked for her between 1770 and 1773. In 1772 Grimm reported that the work was nearly finished and commented that 'Love bore the expense and pleasure designed its plan; no finer temple was ever erected in Greece in honour of this goddess. The drawing room consists entirely of paintings. Mlle. Guimard is depicted as Terpsichore' Then, in 1773, for some unknown reason, Fragonard fell out with Mlle. Guimard. There were inevitable rumours about his relationship with the dancer, and the motive may have been one of personal spite but, more likely, he had grown tired of her haughty, capricious behaviour. The Goncourts report, on Grimm's authority, that to revenge himself Fragonard changed the portrait of her from Terpsichore to the Fury Tisiphone. Although several portraits of Mlle. Guimard by Fragonard survive, there is no trace of the one of her as Terpsichore, mentioned by Portalis as being in a private collection. In any case, Fragonard left the work unfinished and handed it over to the young

Jacques-Louis David. In 1786 Sophie Guimard, heavily in debt, was forced to put her house up for sale by lottery and, after passing through various hands, it was demolished in the nineteenth century.

Fragonard's second and much more important commission in 1770 was to paint a series of decorative panels and overdoors for Mme. du Barry's new pavilion, also by Ledoux, at Louveciennes. These are the panels known as *The Pursuit of Love* (Plates 34a–e), now in the Frick Collection, New York. The story behind this commission and the reason for Mme. du Barry's sudden refusal of Fragonard's panels in 1773 are complex and still not quite clear. Mme. du Barry (1741–93) succeeded in 1769 to the position of Louis XV's recognized mistress, left vacant since the death of Mme. de Pompadour. Du Barry also assumed Pompadour's unofficial role as patroness of the arts, but she had none of her predecessor's artistic and intellectual gifts. Mme. de Pompadour could sketch, draw and play the harpsichord, and when Boucher painted her portrait he showed her surrounded by all the attributes of the arts. Mme. du Barry, who was no less prodigal of the treasury's funds, spent more money on jewellery and clothes than on works of art. She was, however, very anxious to keep abreast with the latest artistic fashions, and this may well be the reason why, having discovered that Fragonard's Rococo style had passed from favour in certain advanced circles, she returned his canvases and handed on the commission to Vien, whose work was also more in keeping with the Neo-Classical exterior of the building. A diluted Etruscan form of Neo-Classicism, suited to the small scale of Parisian drawing rooms, had become the rage in fashionable society and Grimm reports that 'tout est à la Grecque'. 'Everything is in the Greek style.' Fragonard, with his 'shepherds's romances', as Bachaumont slightingly referred to *The Pursuit of Love*, suddenly found himself outdated overnight. Today, however, the pendulum of taste has swung back again, and it needs some effort of the historical imagination to see why Mme. du Barry should have preferred Vien's pleasant but anemic scenes to Fragonard's overwhelmingly beautiful panels.

As their title implies, the subject of the series is the triumph of love, unless the fifth panel, *Abandonment*, also belongs to the sequence. This seems unlikely as Fragonard could hardly have wished to inflict an unhappy ending on his patron. Bachaumont suggested that *The Pursuit of Love* was an allegory on the mistress of the house, and they may allude to the love between Mme. du Barry and Louis XV; some critics have noted that the lover has the king's features. Both the lovers are dressed in the height of fashion, and the scenes are set in an opulent, overgrown garden, with a profusion of urns, columns and shrubs, a little walled enclave threatened by a riot of natural growth. Fragonard treated the scenes like four episodes from a contempor-

ary novelette, but, as in *The Fête at Saint-Cloud*, by the sheer exuberance of his imagination he transformed what might have been vignettes on the scale of Gravelot or Eisen into a work of epic poetry. The lightness and exquisite poise of the figures, and the fact that each episode has a different *mise en scène*, suggest a possible source of inspiration in contemporary ballet. The third panel, *The Declaration of Love*, has all the elegant artificiality of a reconciliation scene between lovers. The girl holding the wreath in the fourth scene has very similar features to the portrait *Study* in the Louvre which bears some resemblance to Sophie Guimard. The sequence of the pictures is easy to read and their meaning plain. In the first, *Storming the Citadel* (Plate 34a), an eager lover clambers up a ladder and over the low wall, disturbing the girl, who seems genuinely startled by the intrusion. In *The Pursuit* (Plate 34b) he comes bearing a rose and breaks up a party 'à deux'; this time the girl trips away coquettishly like a ballet-dancer, but is not displeased. By the third, *The Declaration of Love* (Plate 34c) the lover has already won over his sweetheart, and they exchange a tender message while the statue seems to give her maternal blessing to their union. Finally, in *The Lover Crowned* (Plate 34d), the young man is crowned by the girl with a wreath, and her musical instruments lie scattered on the ground as if to symbolize the victory of love over the arts; meanwhile a young artist is busy sketching the scene for posterity. The feelings and décor of *The Pursuit of Love* are those of Beaumarchais or the young Mozart, for they epitomize the all-absorbing subject which love had become to the late eighteenth century, not 'l'amour passion', with its attendant suffering, but 'la galanterie', the pursuit, the chase and the conquest.

At roughly this point another important patron stepped into Fragonard's life, Bergeret de Grancourt (1715–85). Bergeret was Treasurer-General of Finance for the region of Montauban and the son of a member of that unpopular class of men, the Fermiers-Généraux, the tax collectors under the Ancien Régime. Bergeret was also an immensely rich man, the owner of the château and estate of Nègrepelisse in Languedoc and other properties near Paris. To judge by Vincent's portrait of him (fig. 5) painted in Rome in 1774, Bergeret wearing a turban and in silk pyjamas, he was the epitome of the bloated financier, arrogant, ruthless and opinionated. He had none of Saint-Non's finesse and generosity, but his interest in the arts was genuine. Such a man's luggage was not complete without a painter, and in October 1773 he invited Fragonard and his wife to accompany him to Italy. Bergeret wrote an account of their journey in a series of letters to his nieces in Paris. The party travelled via Uzerches, Brive, Nîmes and Aix-en-Provence, where they admired some fine paintings in the collection of the président d'Albertas, embarked on a boat at Antibes for Genoa, then

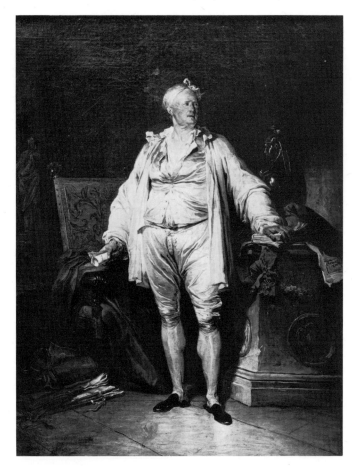

fig. 5 François-André VINCENT
Portrait of Bergeret
Oil on canvas 64 × 37 cm. Signed: Vincent f. Rome 1774. Besançon, Musée des Beaux-Arts

François-André Vincent (1746–1816) later became a prominent history painter. At the time he painted this portrait of Bergeret he was a pupil at the Ecole de Rome.

went on to Pisa and Florence. Prompted no doubt by Fragonard, Bergeret constantly reminded his readers of his visual preoccupations, 'Nous voyons tout en tableau', and he made careful notes of his impressions of people, scenery and works of art. At the beginning he was delighted with Fragonard's company, found him an easy travelling companion and praised him as a 'painter of excellent talent, whom I need particularly in Italy', but after this there is very little mention of Fragonard, perhaps suggesting that Bergeret failed to appreciate the artist's true value. The climax to their journey was Rome, where they arrived on 5 December. Bergeret was so overwhelmed by the city that his journal breaks into a series of exclamations at the sight of so many palaces, fountains, ruins and marbles. There are some interesting pages on the Ecole de Rome, and Bergeret could not find enough praise for its pupils, Vincent, Berthélémy, Suvée, Taillasson and Ménageot. The party was taken on guided tours of Rome by the architect P. A. Pâris, who later inherited many of Fragonard's best drawings and gave them to his native Besançon.

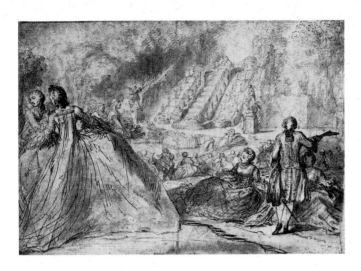

fig. 6 Gabriel de SAINT-AUBIN
The Fête at Saint-Cloud
Black chalk, brown and grey wash 21·3 × 29·9
cm. Edinburgh, National Gallery of Scotland,
Department of Prints and Drawings

In the lower right-hand margin and on the
back the drawing is inscribed: Pater. This is
almost certainly not authentic.

Then, early in 1774, they visited Naples and from there
set back on the long journey home via Venice, Vienna,
where they saw the Prince of Liechtenstein's gallery,
Dresden, Strasbourg and, finally, Paris. On their re-
turn the strain of travelling together for a long period
broke out in a violent quarrel between Fragonard and
his patron. Bergeret struck out his earlier words in
praise of the artist and demanded the right to keep all
the drawings Fragonard had made during the journey
as payment in lieu of expenses. The case was then taken
to court, where it was decided that Bergeret should
return Fragonard's drawings or pay him substantial
compensation. Whatever the rights and wrongs of this
incident it clearly reveals Fragonard's independent
attitude towards his patrons, his confidence in his status
as an artist and his refusal to be treated as a lackey.

It was probably soon after his return from Italy, in
1775, but possibly earlier, that Fragonard was asked
by the duc de Penthièvre to decorate his dining room
in the Hôtel de Toulouse, now the Banque de France.
The result was *The Fête at Saint-Cloud* (Plates 42 and VII),
Fragonard's masterpiece and one of the least known and
most beautiful of all French paintings, the late eighteenth-
century pendant to Watteau's *Embarkation for Cythera*.
The setting is the park of the Château de Saint-Cloud,
just outside Paris, which then belonged to the royal
family but was freely open to the public. This is what
the countryside meant to the metropolitan artist and
his public at the time, just as Montmartre was country
to Nerval and Asnières to Renoir. About 1750 the
French attitude towards the country began to change.
After a century of metropolitan life centred on the
court people started to hanker after the rural retreat.
'Tout le monde est maintenant à la campagne.' 'Every-

body is in the country today' wrote the Abbé Raynal
in October 1750. Nobles and financiers spent up to a
previously unthinkable six months on their estates,
bourgeois bought up villas in the Ile de France, poets
retired to their 'ermitages', while the working popula-
tion had to be content with a day out in the country.
Saint-Cloud might be compared to Vauxhall Gardens
in eighteenth-century London and provided the same
kind of diversions for the people of Paris. Every year,
on the last three Sundays of September, a festival was
held when the fountains played and entertainment was
provided by actors, dancers, fireworks, booths and
puppet shows. This custom was maintained after the
Revolution, when the park became state property. Not
only the fashionable visited Saint-Cloud; it was also the
favourite rendez-vous of artists like Gabriel de Saint-
Aubin (fig. 6) and Hubert Robert, who found a ready-
made subject in its varied spectacle. By far the most
numerous visitors were the petits bourgeois and artisans
of Paris, the shop-girls and dressmakers who flocked
there in boatloads down the Seine and then crowded on
to carts for the rest of the journey. After a day's riotous
entertainment and a supper of vinegary wine and badly
cooked meat at exorbitant prices, they would make their
way happily home through the woods. These are the
spectators, graphically described in L. S. Mercier's
Tableau de Paris, we see in Fragonard's picture. Some
are grouped round the puppet show, some are playing a
game something like roulette, others are watching the
actors, while a few are content to loll idly with their
sweethearts (Plate VII). The whole picture is composed
of a series of delightful vignettes and yet is conceived on
a vast, epic scale, unified by the enormous Italianate
trees which seem to dwarf the human figures and
reduce their activities to mere antics. All natural growth
is larger than life; even the fountain is denser and more
powerful than a real one. Does this mean that Fragonard
has invested nature with superhuman powers and pro-
duced a kind of pantheistic vision close in spirit to
Rousseau? He has been considered as a precursor of
the pre-Romantic sensibility in which ominous, uncon-
trollable forces threaten to reduce mankind to insigni-
ficance; witness the broken capital in the centre and
the menacing presence of the statue on the right, like
the Commendatore in Mozart's *Don Giovanni*. Are these
symbolic of decadence, or are they simply the com-
positional devices which Fragonard, like Hubert
Robert, found irresistible?

This streak of Romanticism seems, at first sight, even
more predominant in *The Fête at Rambouillet* (Plate VIII),
with its gnarled Salvatorial tree in the centre and its
foaming, rocky waters like an eighteenth-century
version of Poussin's *Deluge*. There is, however, nothing
really sinister in this picture; it is simply a party enjoy-
ing the thrill of pretending itself out in a storm at sea,
an elaborate charade designed to give the public the

same kind of vicarious frisson which scenes of shipwrecks by Vernet and Loutherbourg gave to city-dwellers who had never been near the sea in their lives. This does not, of course, argue against Fragonard's Romanticism, indeed this kind of flirtation with danger and quest for substitute experience is one of its most deeply-rooted characteristics.

With these two great decorative park scenes Fragonard at last came into his own. They are his unique personal creation. He had evolved a genre which, if not entirely new, was to stand him in good stead for the next decade and made a major contribution to French art. It was also in the 1770s that he painted the marvellous panels in Washington, *The Game of Hot Cockles, Blind Man's Buff* (Plate 35) and *The Swing* (Plate 36). Building upon his empirical observations of nature in Italy, Fragonard magnified his chalk sketches and translated them into a new modern idiom which reflected contemporary French life with the same delicate precision and imagination as Watteau. The Goncourts were right to see Watteau and Fragonard as the two poets of the eighteenth century, for there is always an element of the fantastic, for example the weird shape of the mountain in the distance of *The Swing*, which lifts Fragonard far above the minute, literal transcription of outdoor scenes by Gabriel de Saint-Aubin (fig. 6), who, although he may, in a narrow sense, have been the inventor of the genre, nevertheless, remained a superficial observer. While all the details in *The Swing* are perfect in themselves as pieces of realistic observation, the woman playing with the dog, another woman peering through a telescope into the distance, they are only the elements in Fragonard's epic vision of landscape. For the first time, perhaps, in the eighteenth century he raised decorative painting to the level of great art.

In all Fragonard's best work there is this fine balance between fantasy and reality. It was, understandably, the naturalistic side of him which attracted the Impressionists, especially Renoir, who looked to Fragonard as a pioneer in the art of showing people reading, musing, or doing nothing in particular. They felt a special affection for paintings such as *The Music Lesson* (Plate 22) and the *Woman Reading* (Plate 46), which seem to distil the very essence of French domestic life in the eighteenth century. This affinity, which extends to colour and texture, is particularly close in Renoir's female portraits, while his *Grandes baigneuses* of 1887 can be seen as a distant reply to Fragonard's own *Bathers* (Plate 18). For the late nineteenth century Fragonard seemed like a precursor of their notion of the 'painter of modern life', a recorder of the way of life and leisure pursuits of a particular society. There is an interesting reflection of this view of Fragonard in Marcel Proust's *La Prisonnière*, where the narrator tries to telephone Andrée but only succeeds in arousing the

fury of 'implacable deities'. 'As I waited for her to finish her conversation, I asked myself how it was—now that so many of our painters are seeking to revive the feminine portraits of the eighteenth century, in which the cleverly devised setting is a pretext for portraying expressions of expectation, spleen, interest, distraction—how it was that none of our modern Bouchers or Fragonards had yet painted, instead of "The Letter" or "The Harpsichord", this scene which might be entitled "At the Telephone", in which there would come spontaneously to the lips of the listener a smile all the more genuine in that it is conscious of being unobserved.' The nineteenth-century nostalgia for the eighteenth century has rarely been better expressed, for Proust, like the Goncourt brothers, believed that the painters of the Ancien Régime were a greater credit to French art than all the 'doctrinaire' artists of the Revolution put together.

Fragonard was, finally, one of the most brilliant literary illustrators of all time. In his drawings for the *Orlando Furioso* (Plates 39a – f) and *Don Quixote* (Plates 48a, b) he revealed himself equal in creative power to the original writers, and his rapid understanding sent him straight to the meaning of a text. Examples of French literature from his own time do not seem to have fired Fragonard's imagination to the same degree. He illustrated subjects from Marmontel, from Mme. de Genlis's *Les Veillées du château* and from La Fontaine's *Contes* (Plates 57a, b), but they are hardly his most inspired creations. He was no intellectual, and his contacts with the major writers and thinkers of his own day were minimal; there is nothing to show that writers thought very highly of him in return. And yet Fragonard's art seems inseparable from the eighteenth-century mould of thought. His great decorative scenes, after all, coincide with the celebration of natural creation in Rousseau and Bernardin de Saint-Pierre, while many of his 'galant' subjects provide an almost exact complement to the poems in Parny's *Poésies érotiques*. His closest affinity is perhaps with Diderot, and it is more than a coincidence that the great collector Hippolyte Walferdin associated the writer and the artist in a twin cult. Fragonard's art has all the contradictions, the variety, exuberance and flexibility of Diderot's prose, the same alternating flights of fancy and earthy Rabelaisian humour. He had too the same unreflecting, spontaneous creative urge as Diderot, the same Protean mobility. Such literary parallels should not be pushed too far, however, even in an age when literature and painting tended to go hand in hand. For where Fragonard was most original and least like other eighteenth-century painters was in his awareness of the artist as a unique being, subject to that irrational element, inspiration. Anyone wishing to show that 'genius' was the invention of the late eighteenth century might well find proof in drawings like *Ariosto Inspired by Love and*

Folly (Plate 39a), the *Homage to Gluck, The Poet's Inspiration* or *Plutarch's Dream* (Plate 16). These strange drawings are all clearly related in theme and style and perhaps tell us more about Fragonard's ideas, tastes and view of himself than any other work. They form a kind of miniature Pantheon; each one is dedicated to an artist-hero, who sits contemplating some fantastic vision in his mind's eye. The drawing of Ariosto, which might possibly have served as a frontispiece to Fragonard's projected edition of the *Orlando Furioso*, shows the poet crowned with laurels sitting barefoot on a stone bench gazing at the two presiding geniuses of his poem, Love and Folly. The next, *Homage to Gluck*, with a poet seated in front of three busts of Gluck, Homer and Virgil and a slab inscribed 'AMANTI DEGLI (sic) ARTI', was probably intended to celebrate the performance in Paris of *Iphigénie en Tauride* in 1779. It was followed by *The Poet's Inspiration*, or *Homage to La Fontaine*, showing the same poet in front of busts of Erato, La Fontaine and Rousseau, and finally by *Plutarch's Dream* (Plate 16), a figure seen reading a copy of Plutarch's *Lives of Famous Men*, with scales, one balance bearing the inscription 'Grandeur', the other 'Médiocrité'. These four apparently insignificant drawings reveal Fragonard as a man of strong intellectual sympathies, with a quasi-Romantic belief in the poet, musician or painter as a visionary, blessed with a divine gift. It only remained for writers to state this idea in words for it to become common currency in the nineteenth century.

The remainder of Fragonard's career can be briefly told, for although he lived on until the age of seventy-four, his period of greatest creativity was over. In 1780 his son, the painter Alexandre-Evariste, was born at Grasse, and in 1788 he was severely shaken by the death of his only daughter Rosalie. Meanwhile the newspapers published a steady stream of engravings after his most popular compositions, *The Bolt* in 1784, *The Fountain of Love* in 1785 and *The Stolen Shirt* in 1787, all of which attests to Fragonard's continuing popularity with the general public. It was also after 1780 that he began to paint the allegorical, mythological works which have earned him the epithet 'a Romantic before the Revolution'. One of these is entitled *Homage Rendered to Nature by the Elements* (now lost, Wildenstein cat. no. 490), or, more poetically, *Le réveil de la nature*, and shows a draped and hooded statue of Nature on a pedestal, surrounded by a flurry of cupids, eagles, doves and a pair of fawning lions at her feet, the whole of nature come to pay homage to its source. On paper this sounds a typically eighteenth-century subject, but there is something artificial and fantastic about it which looks forward to Prudhon or Girodet. There is also an unmistakably nineteenth-century quality about *The Fountain of Love* (Plate 58), with its two lovers drawn as if by magnetic force to the fountain, the symbol of desire. Although they are supposed to convey violent move-

ment, the figures are linked in a symmetrical, statuesque outline more suggestive of Neo-Classical immobility. Even more like Prudhon is the strange, allegorical *Sacrifice of the Rose* (Wildenstein cat. no. 497) showing a fainting, naked woman, one of love's victims, with a cupid burning a symbolic rose on the altar of sacrifice. These curious works, which may have obscure literary origins, indicate that Fragonard's mind had already taken on a distinctly Romantic cast well before such subjects became popular in the nineteenth century. This does not mean that he renounced his 'galanteries', as we can see from the late *Stolen Kiss* (Plate 55) or *The Bolt* (Plate 56); only that his style, with the direct or indirect help of Marguerite Gérard, had undergone a subtle modification. The chubby, naked bodies of the earlier erotic pieces gave way to the tall willowy form of the girl in *The Stolen Kiss*, who snatches at her satin scarf and lets herself be furtively kissed while her parents or relatives next door carry on with their card game unawares. The whole scene is one of the most perfect late eighteenth-century interiors ever painted.

In 1789 Fragonard was overtaken by the Revolution. As the protégé of not particularly enlightened members of Ancien Régime society he can hardly have welcomed the event, but with his customary flexibility he managed to survive the worst years and even modestly to prosper. In an effort to ingratiate themselves with the new authorities, his wife and Mlle. Gérard offered their jewels to the National Assembly in 1789. Then in 1790 Fragonard prudently moved with his family from Paris to Provence, where they stayed with his cousin Alexandre Maubert at Grasse. When the Terror was over they returned to Paris, and in 1792 Alexandre-Evariste entered the studio of David, by then the most important and influential painter in France. David had a great respect for Fragonard, and it was perhaps out of gratitude for an earlier kindness that he recommended the elderly artist for membership of the newly-formed Museum des Arts, an administrative post which saved Fragonard from penury and entitled him to free lodgings in the Louvre. These he was compelled to leave in 1805 when the Emperor Napoleon decided to take over more of the Louvre for use as a museum. Fragonard then went to live in the Palais Royal. He died on 22 August 1806 on his way home from a restaurant, an obscure and forgotten figure, a relic of the vanished society which had idolized him. His art was then totally eclipsed for at least the next thirty years. After 1830 certain minor Romantics like Devéria began to make engravings after Fragonard, but it was only about the middle of the nineteenth century that Daumier and collectors like La Caze and Walferdin took a serious interest in him. The Goncourt brothers's study of 1865, supported by Portalis's monumental book of 1889, further confirmed Fragonard's growing reputation, but in our own century this has again ebbed and is by no means

universally recognized. Fragonard remains a great unknown figure among French artists.

The reasons for this comparative neglect are complex. In the first place his art is widely dispersed all over the world, and it is not easy to form a complete picture of it from any single collection. His greatest work, *The Fête at Saint-Cloud*, has very rarely been on public exhibition. Another reason may be the egalitarian bias of our own age which has brought about a shift of interest away from the Ancien Régime, with which Fragonard was associated, towards the more democratic art of the Revolution. A third and perhaps still more decisive reason why Fragonard is given short shrift is the tendency among some art historians to identify painters with a particular cultural or historical phase of civilization. Thus, Watteau becomes the painter of the Régence, Boucher of the reign of Louis XV and the Pompadour style, Chardin is the representative of the humble artisan class, Greuze the leader of the moral reaction away from Rococo frivolity and David the hero of the Revolution. In this oversimplified scheme there is no place for such a complex and variable artist as Fragonard, who cannot readily be linked to any such movement or intellectual trend and who defies all attempts at categorization.

The truth is, perhaps, that he touched on all these different strands without being bound by any one of them. Sometimes his work harks back nostalgically to the Régence of Watteau, at others it seems to herald the mood of the Revolution. This inconsistency of style and lack of a single-minded purpose make him the outstanding individual among eighteenth-century painters. He was the supreme improvisor, dashing off sketches often without much thought for the finished product; although when he worked for patrons he painted to satisfy himself as much as his client. In his later works especially he seemed to strive after an entirely free form of self-expression, independent of the accepted genres and categories of his time. Unlike Chardin and Boucher, who belonged more to the old-fashioned type of artist-craftsman, Fragonard was not content to execute technically perfect works within a narrow range. His restless impatience, lack of concern with form and sheer delight in creation, even at the cost of carelessness, made Fragonard, in one sense, more typical of the nineteenth-than the eighteenth-century painter. And yet, in another sense, he seems the typical artist of the Ancien Régime. His art epitomizes a period of aristocratic leisure, romps in parks, swings, games of blind man's buff, harlequinades, idle noblemen with nothing better to do than loll in the grass, unreflecting people enjoying themselves in happy oblivion of the harsher aspects of eighteenth-century life. Here Fragonard takes us back to Watteau's enchanted magic fantasies, such as the *Champs Elysées* in the Wallace Collection, with small groups of people nonchalantly strolling in parks opening out into vast blue perspectives.

Fragonard, however, has none of Watteau's melancholy and sense of decadence, unless we write this off as the invention of Nerval, Gautier and other Romantic critics, all too ready to discover precocious symptoms of the *mal du siècle* in the eighteenth century. This difference of outlook, passive and diffident in Watteau, robust and optimistic in Fragonard, may partly be ascribed to temperament and background, but also to a change in the climate of the times. People in late eighteenth-century France did not live in fear and trembling of the impending Revolution. Until 1780 at least it was a period of hopeful optimism, when the Encyclopédistes believed that they could put the world to rights if only they could persuade a well-intentioned king and government to carry out some necessary practical reforms. Even the more enlightened members of the nobility, swayed by the fashionable new ideas, were prepared to sacrifice some of their privileges, and the art and literature of the time are full of well-born people who willingly, perhaps condescendingly, abdicate their social status to lead simpler lives. There was a greater mixing of the social classes than ever before in France, certainly than in the seventeenth century, dominated by hierarchy and etiquette. This new informality and move away from court and urban life lies at the core of Fragonard's art. Thus we find in his pictures not only privileged aristocrats, as in Watteau's, but also plebeians enjoying a day out in the country, stable lads and village schoolmistresses, young girls of all classes of society, reading, writing, making love. We already seem to be in a world where the barriers have broken down, indeed Fragonard seems blithely unaware of their existence. In this sense his art is far more representative of life in eighteenth-century France than either Watteau or Boucher, even though the Goncourts saw Boucher as the typical painter, the 'incarnation' of the period, while being far less confined to a particular aspect of taste. By his sheer lack of inhibition, by his range and variety, his willingness to tackle anything which came his way, Fragonard managed to create a microcosm of the Ancien Régime, with all its contradictions and growing tensions well buried below a surface of hedonistic enjoyment.

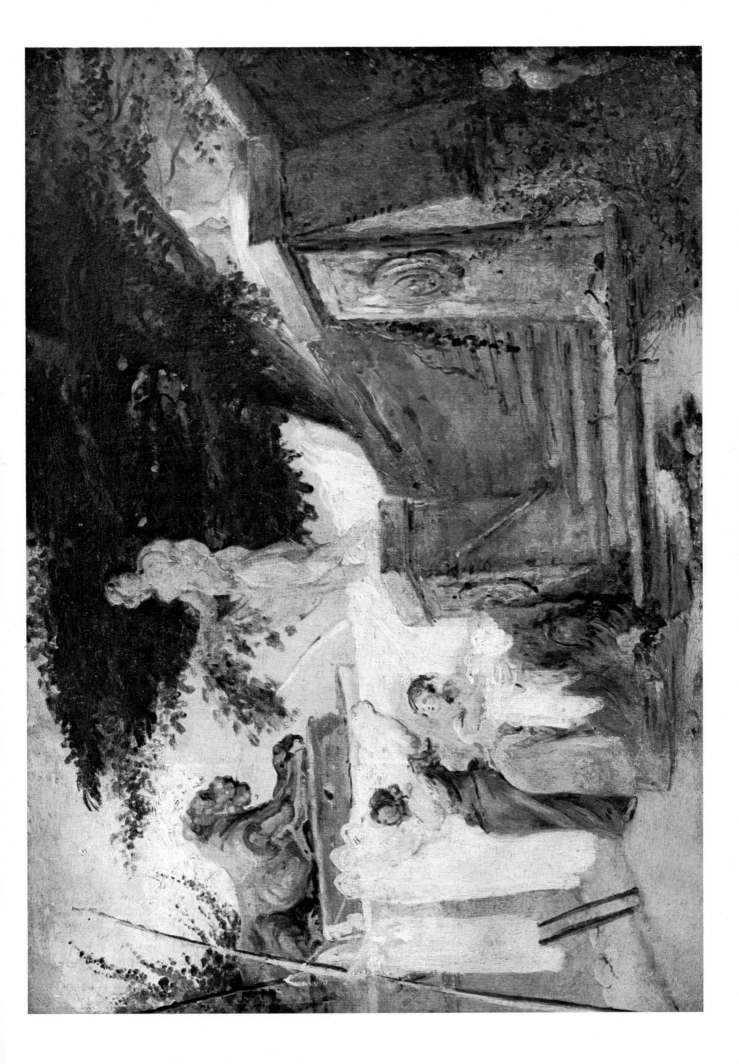

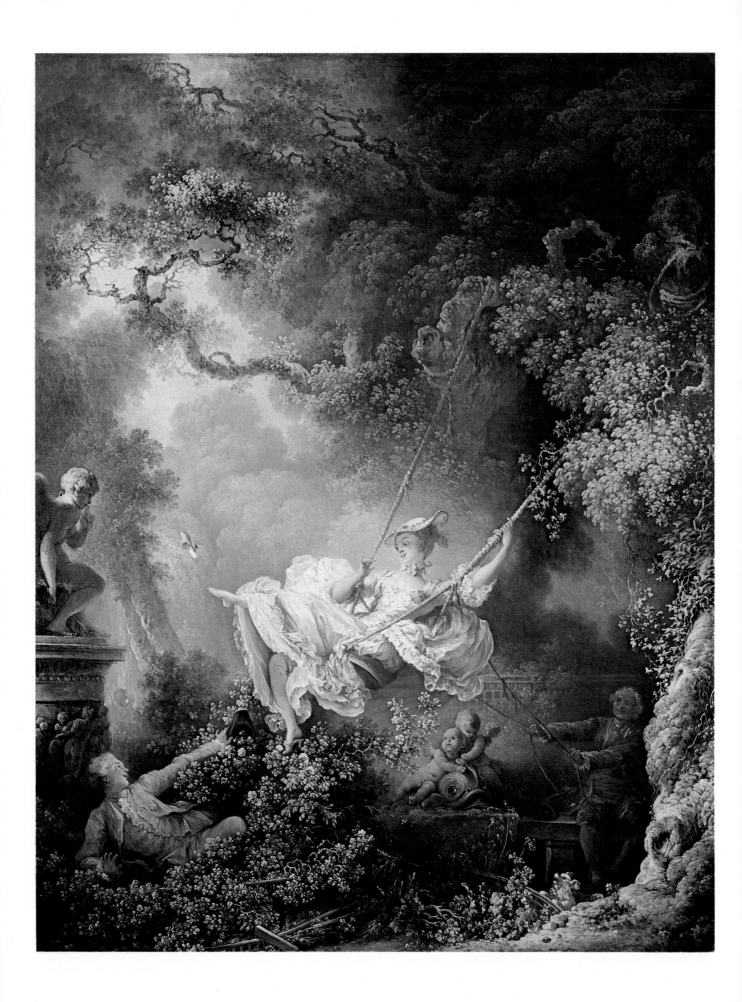

1 *Woman Gathering Grapes*
formerly CHICAGO, collection of Mrs. Fowler McCormick.
c. 1750. Oil on canvas in gilt frame 149 × 83 cm.

This is an early work in which Boucher's influence is
manifest in the smoky blue-green tonality and the
picturesque rusticity, with random objects scattered in
the foreground and the characteristic dovecot in the
background. A comparison between the *Woman
Gathering Grapes* and the great park scenes of the 1770s
shows how far Fragonard outgrew Boucher's genteel
pastorals, although there is already a hint of Fragonard's
individual style in the animal zest of the two children
and the sidelong glance of the young woman. Paintings
like this were perhaps intended to be reproduced by the
Gobelins tapestry factory.

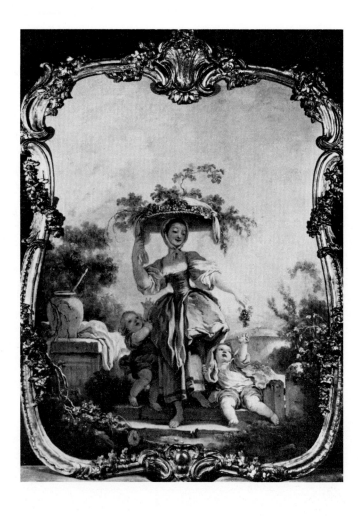

(*page 17*)
I *The Washerwomen*
AMIENS, Musée de Picardie. c. 1761–62. Oil on canvas 47 × 65 cm.

Given to the Musée de Picardie by the Lavalard brothers in 1894, *The Washerwomen* belongs, with
The Waterfall at Tivoli (Plate 11) and *The Gardens of the Villa d'Este* (Plate 12), to the group of
paintings produced in the years immediately following Fragonard's return from Italy to Paris in
1761. The site of this particular painting is not known, but the crumbling decay of the steps and
statues gives a good idea of the state of the Villa d'Este gardens when Fragonard stayed there in
1760. Hubert Robert and Fragonard both liked to paint this vision of classical Antiquity, decaying
but still in daily use by the washerwomen who strung out their lines from one statue to another.

(*left*)
II *The Swing*
LONDON, Wallace Collection. 1766 or 1767. Oil on canvas 81 × 65 cm.

In 1859 the duc de Morny offered *The Swing* to the Louvre, which turned it down, and it was
bought instead by Lord Hertford in 1865 for 30,000 francs. The painting was commissioned from
Fragonard by the baron de Saint-Julien in 1766. In his *Journal*, Collé relates how Saint-Julien first
approached the history painter Doyen for a picture of his mistress on a swing, with a bishop
standing by and the baron lolling in the grass in a strategic position from which to observe the
girl's legs. Doyen indignantly refused the commission and handed it on to Fragonard, who carried
out the picture according to Saint-Julien's wishes, except that in place of the bishop he put an
acquiescent husband on the right in the background, giving a helpful push to the swing. The statue
of Cupid on the left is probably Falconet's *L'Amour menaçant* from the Louvre, exhibited at the
Salon of 1757.

2 *The Four Seasons*

Winter. LOS ANGELES, Los Angeles County Museum of Art (William Randolph Hearst collection).
Oil on canvas 80 × 164 cm.

The Four Seasons were executed around 1750–52, still very much in the manner of Boucher, as
decorative overdoors for the salon of the Hôtel Matignon, 57 rue de Varenne, Paris. They were
probably commissioned by the owner, the duc de Valentinois, formerly Jacques I, Prince of
Monaco, who died in 1751. The building then became the Austro-Hungarian Embassy and is now
the Présidence du Conseil. Only three of the original panels are still in place. The fourth, *Winter*,
was removed and sold when the house was remodelled soon after its construction.

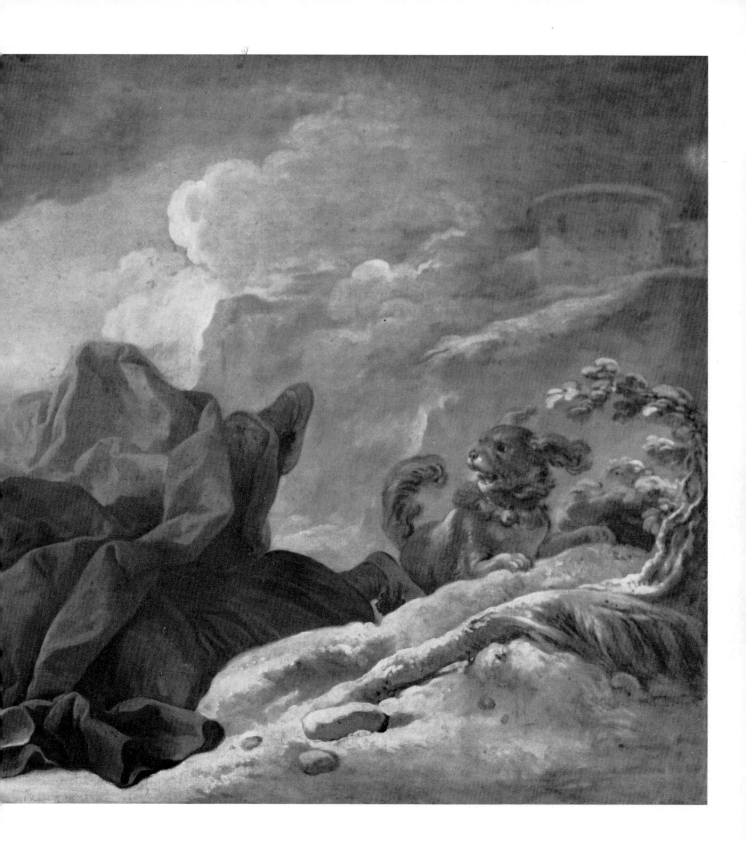

(overleaf)
3 Blind Man's Buff
TOLEDO (OHIO), Toledo Museum of Art (gift of Edward Drummond Libbey). c. 1750–52. Oil on
canvas 114 × 90 cm.

Clearly painted as a pendant to *The See-saw* (Plate 4), which it resembles in style and size, *Blind
Man's Buff* was possibly commissioned by the baron de Saint-Julien. An early work, the lively
handling of the paint and cheerful disorder of the composition betray the influence of Boucher. In
fact, both this painting and *The See-saw* were thought by the Goncourts (*L'Art du dix-huitième siècle*,
vol. III, p. 331) to be simple pastiches of Boucher. There are two other versions, neither accepted
by Wildenstein, one large panel in the Petit Palais, Paris, and another in the Walters collection,
New York.

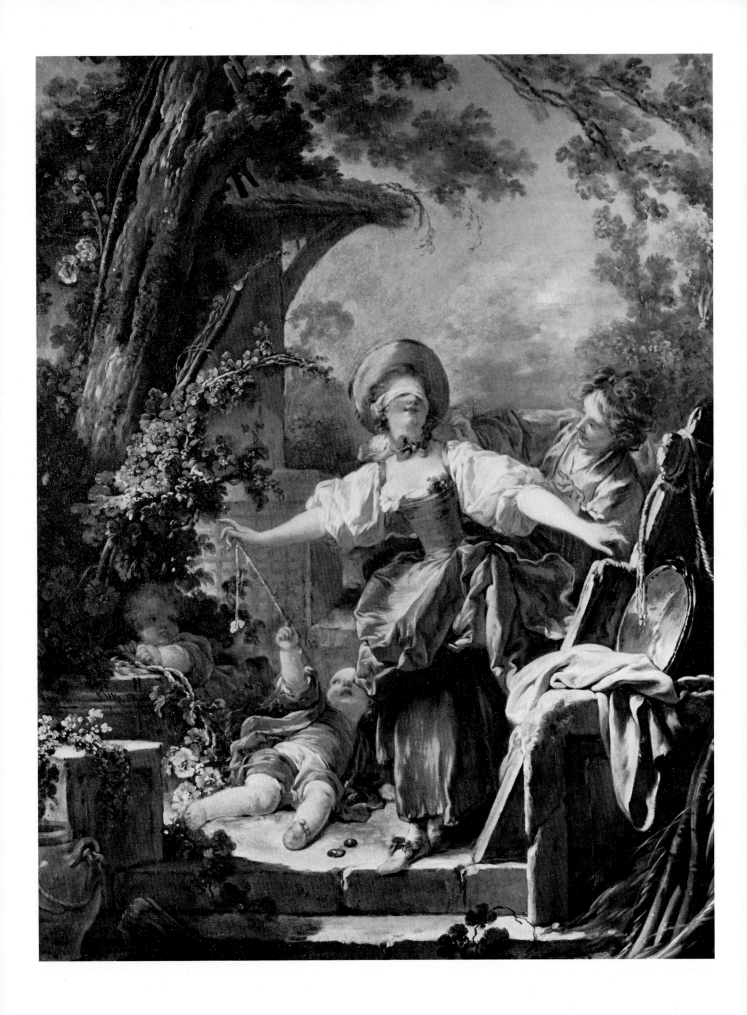

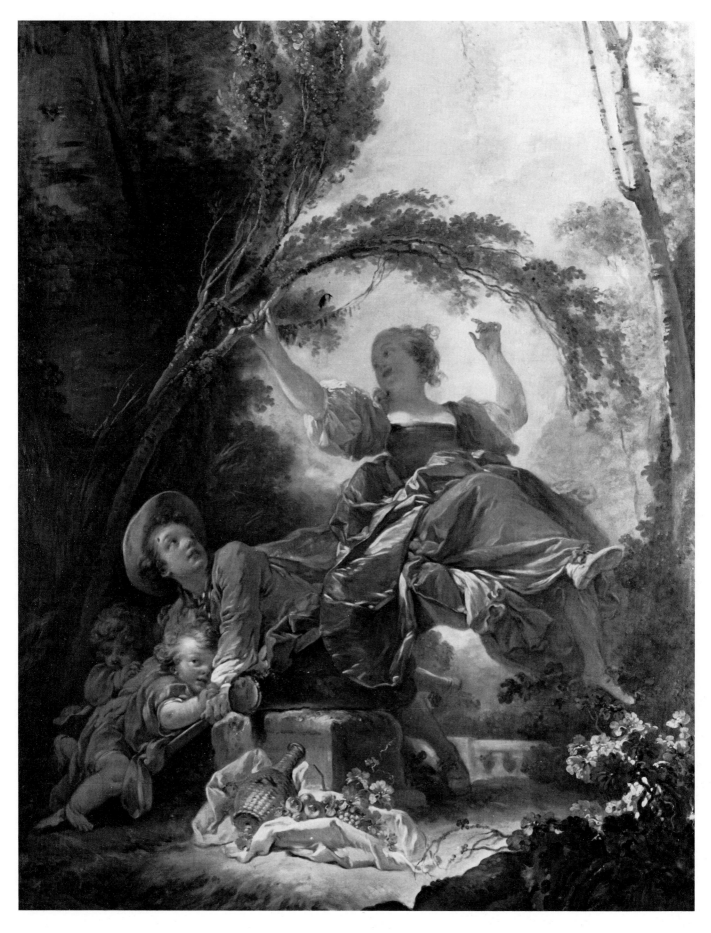

4 *The See-saw*

AMSTERDAM, Stichting Collectie Thyssen-Bornemisza. c. 1750–52. Oil on canvas 114 × 90 cm.

The pendant to the Toledo *Blind Man's Buff* (Plate 3).

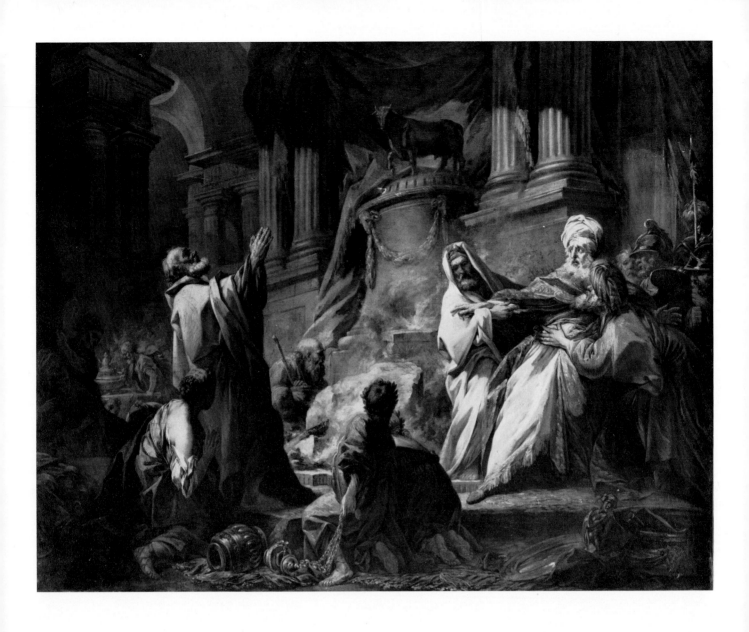

5 *Jeroboam Sacrificing to the Golden Calf*
PARIS, Ecole des Beaux-Arts. Oil on canvas 115 × 145 cm.

Presented by Fragonard for the Prix de Rome in 1752, the painting was awarded first prize. The second prize was won by Gabriel de Saint-Aubin. This work is Fragonard's first essay in the grand historical style, which he quickly mastered, a remarkable achievement for a young artist of twenty who had received no academic training. A clear statement of the painter's adherence to the Rubéniste, colourist faction which triumphed in French art during the first half of the eighteenth century, it contains a strong reference to Poussiniste classicism in the superbly modelled incense bearers in the foreground. The Goncourt brothers wrote of this picture that 'The animated groups, the lively draperies, the cloudy splendour of the architecture, the whites and reds, the colour of a more vaporous, wash-like de Troy promise a great deal for Fragonard's future as a painter.'

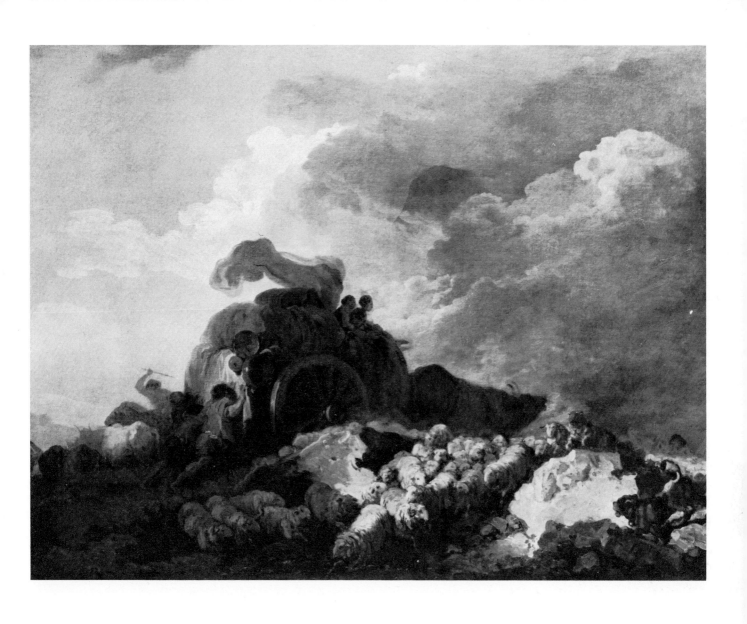

6 *The Storm*

PARIS, Musée du Louvre. c. 1759. Oil on canvas 73 × 97 cm.

Passing from the La Caze collection to the Louvre in 1869, *The Storm* is the subject of a preparatory
study in the Art Institute of Chicago, executed in brown chalk, signed and dated: Rome, 1759.
The painting is probably derived from a landscape drawing by Castiglione (1610–65), perhaps
The Pastoral Journey (Louvre, Cabinet des Dessins), and yet there is something unmistakably
Northern in the ominous, lowering sky which clearly anticipates English landscapes by Crome and
Gainsborough. Fragonard could transform an everyday episode from a farmer's life into a
momentous drama.

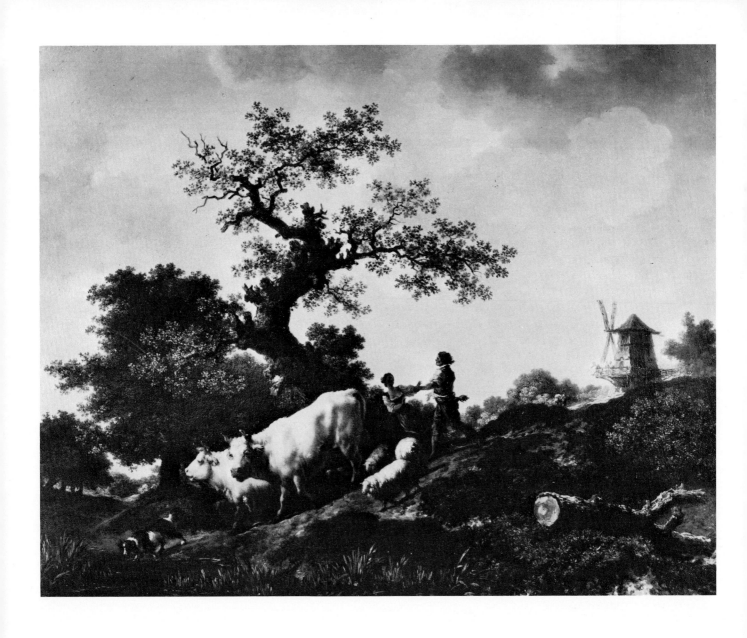

7 *Annette and Lubin*
WORCESTER (MASSACHUSETTS), Worcester Art Museum (gift of Theodore and Mary Ellis). c. 1762–65.
Oil on canvas 65 × 80 cm.

Fragonard painted several versions of this theme, including *Annette at the Age of Twenty* in the Galleria
Nazionale d'Arte Antica, Rome, and its pendant, *Annette at the Age of Fifteen*, now lost, but engraved in
1772 by F. F. Godefroy. Godefroy's engravings after both these pictures were announced in the *Mercure
de France* in 1772. The subject is taken from the story 'Annette et Lubin' in the *Contes Moraux* (1762),
a collection of short pastoral idylls by Marmontel, and relates the love of two cousins, innocent
young shepherds; Annette, finding herself pregnant, is told by an officious local judge that she has
committed mortal sin and forbidden to marry her lover. Fortunately a benevolent squire comes to
the rescue and obtains a special dispensation from the Pope for the cousins to marry. J. F. Marmontel
(1723–99) was one of the most popular writers of his day, a prominent literary critic, friend of
Mme. Geoffrin and editor of the *Mercure de France*.

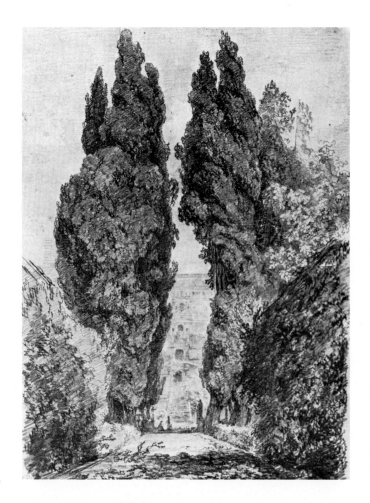

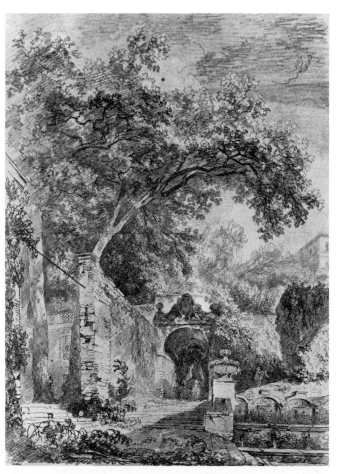

8 *The Giant Cypresses at the Villa d'Este at Tivoli*
BESANÇON, Musée des Beaux-Arts. Brown chalk on white
paper 47·8 × 35·4 cm.

Collections: Saint-Non; P. A. Pâris; Bibliothèque
Municipale de Besançon.

9 *The Entrance to Fontanone at the Villa d'Este*
BESANÇON, Musée des Beaux-Arts. Brown chalk on white
paper 48·8 × 36·1 cm.

Collections: Saint-Non; P. A. Pâris; Bibliothèque
Municipale de Besançon.

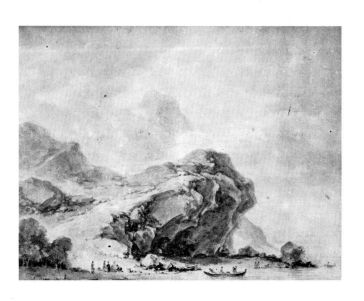

10 *View of the Coast near Genoa*
BESANÇON, Musée des Beaux-Arts. Pen and bistre wash on
pencil sketch 35·3 × 46·2 cm. Signed on the left at the
bottom: Fragonard.

It probably was executed during Fragonard's second visit
to Italy in 1774. Collections: Bergeret (?); P. A. Pâris;
Bibliothèque Municipale de Besançon.

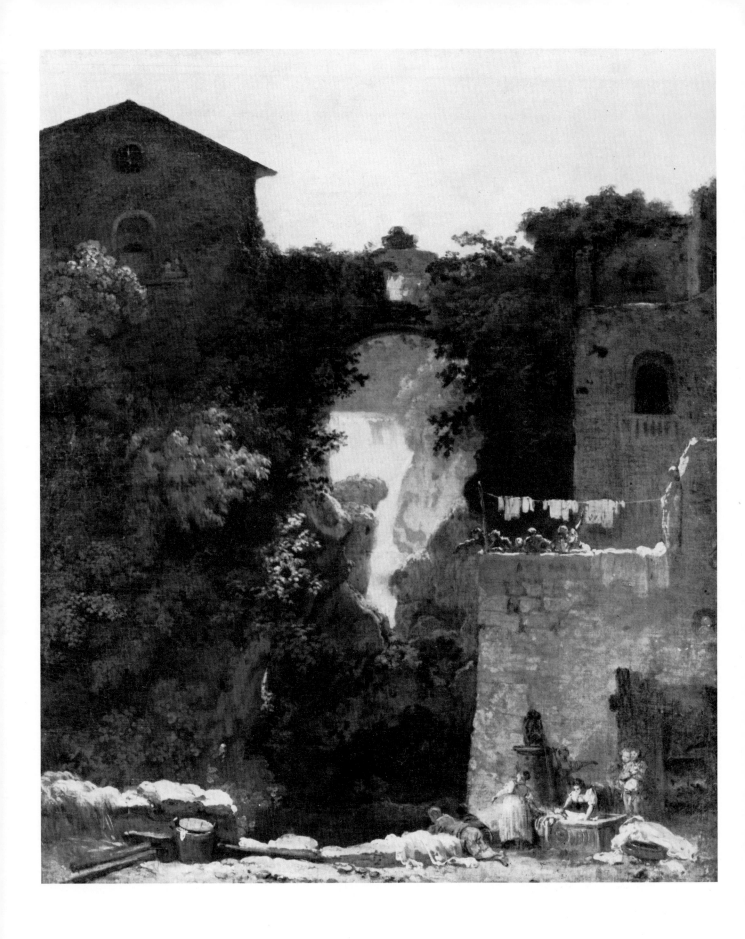

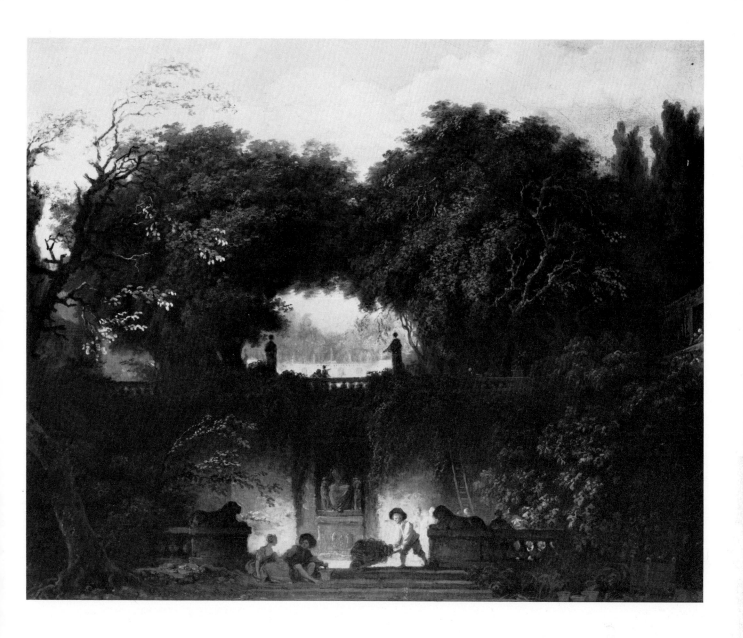

12 *The Gardens of the Villa d'Este at Tivoli*
LONDON, Wallace Collection. c. 1762. Oil on canvas 38 × 46 cm.

Engraved by Fragonard in 1763 and by Saint-Non, the painting was exhibited at the Salon de la
Correspondance in July 1785. One of the views of Italy painted soon after Fragonard's return to
Paris in 1761, it is similar in style and subject to *The Waterfall at Tivoli* and *The Washerwomen*. The
wonderful precision and firmness of these paintings was the result of many preparatory drawings
which Fragonard made in the summer of 1760 at the Villa d'Este in the company of Hubert Robert
and the abbé de Saint-Non.

(left)
11 *The Waterfall at Tivoli*
PARIS, Musée du Louvre. c. 1761–62. Oil on canvas 73 × 60 cm.

Given to the Louvre from the La Caze collection in 1869, this picture is probably the one mentioned
in the inventory of Saint-Non's collection (1792) as 'Paysage avec cascades et figures, vue de
Tivoli'. Formerly attributed to Hubert Robert, it was restored to Fragonard's authorship by
Charles Sterling. Despite a close affinity between the two artists, detailed inspection shows that
Fragonard's technique is much bolder and less meticulous than Robert's, in, for example, the washing
on the line, which consists solely of small patches of white paint. The sheer technical mastery and
spontaneity, disciplined by compositional rigour, of this and the other Italian landscapes have
rarely been surpassed.

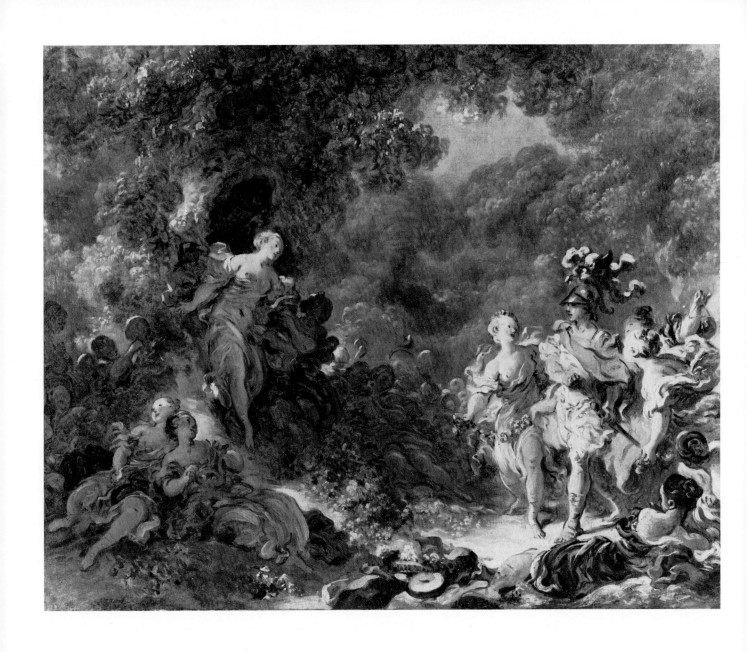

13 *Rinaldo in the Gardens of Armida*
PARIS, collection of M. Arthur Veil-Picard. 1761–65. Oil on canvas 72 × 91 cm.

The subject is from Canto XVI of Tasso's epic poem, *Gerusalemme Liberata*. It is unlikely, however, that Fragonard had read Tasso in the original text, and his immediate source would seem to be the opera *Renaud et Armide* by Lulli and Quinault, performed in Paris in 1761 and 1764. The Rococo theatricality of this picture invites comparison with Tiepolo, who also painted a version of Rinaldo and Armida, 1750–55 (Chicago, Art Institute); but whereas Tiepolo showed Rinaldo seated by Armida's side, Fragonard, with his love of impetuous movement, chose the moment when Rinaldo bursts on to the stage like an operatic hero. Both this picture and its pendant (Plate 14) show that Fragonard had already developed his own individualistic, highly coloured idiom.

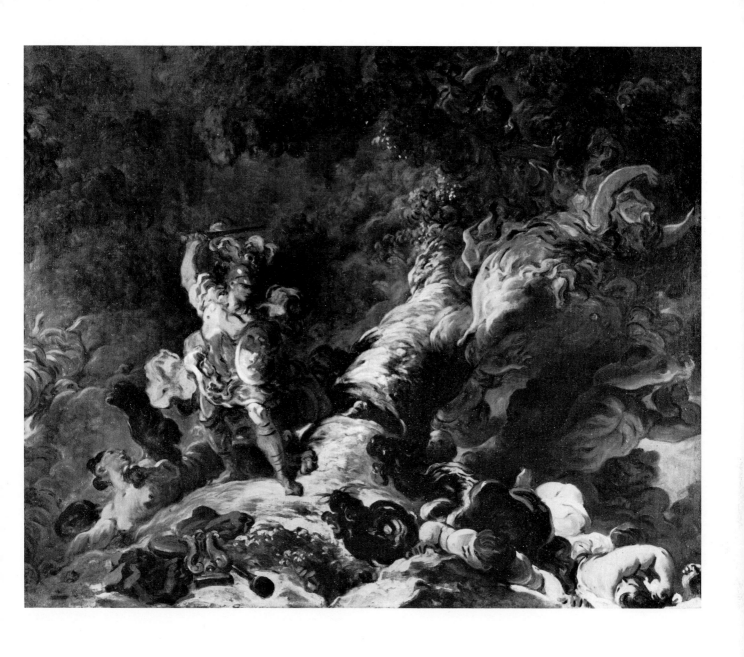

14 *Rinaldo in the Enchanted Forest*
PARIS, collection of M. Arthur Veil-Picard. 1761–65. Oil on canvas 72 × 91 cm.

The pendant to Plate 13.

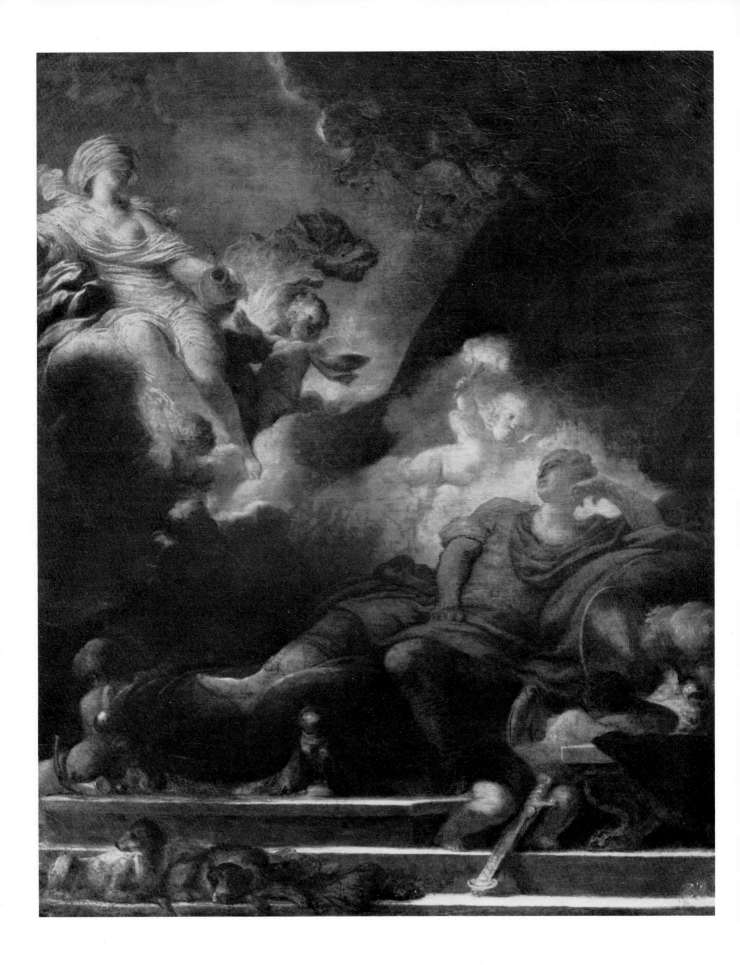

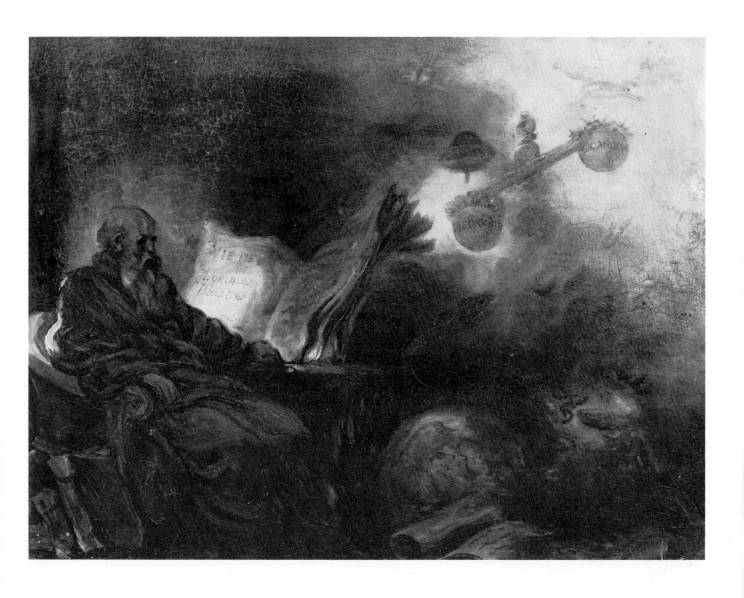

16 *Plutarch's Dream*
ROUEN, Musée des Beaux-Arts. Oil sketch on canvas 24 × 31 cm.

Although catalogued by Wildenstein (cat. no. 85) as an early work, *Plutarch's Dream* would seem to belong to the group of literary compositions of the 1770s. The historian is seen reading a copy of his *Lives of Famous Men*. The painting was acquired by the Musée des Beaux-Arts, Rouen, in 1818. There is a drawing of the same subject in the collection of Mme. Fernand Halphen, Paris (Ananoff, fig. 154, cat. no. 453).

(*left*)
15 *The Warrior's Dream* or *Le Songe d'amour*
PARIS, Musée du Louvre. c. 1761–65. Oil on canvas 60 × 50 cm.

Given to the Louvre in 1915 by the baron de Schlichting, *The Warrior's Dream* is one of Fragonard's allegorical, quasi-literary compositions, comparable to *The Sculptor's Vision* and *Plutarch's Dream* (Plate 16). It shows a warrior, dressed in a toga, asleep; Venus appears to him in a dream. It is not clear whether this picture has a precise source, but its mixture of dream, war and erotic fantasy relates it to the world of Ariosto and Cervantes; or perhaps it is only a variant on the theme of Mars disarmed by Venus, popular with many French artists around 1760.

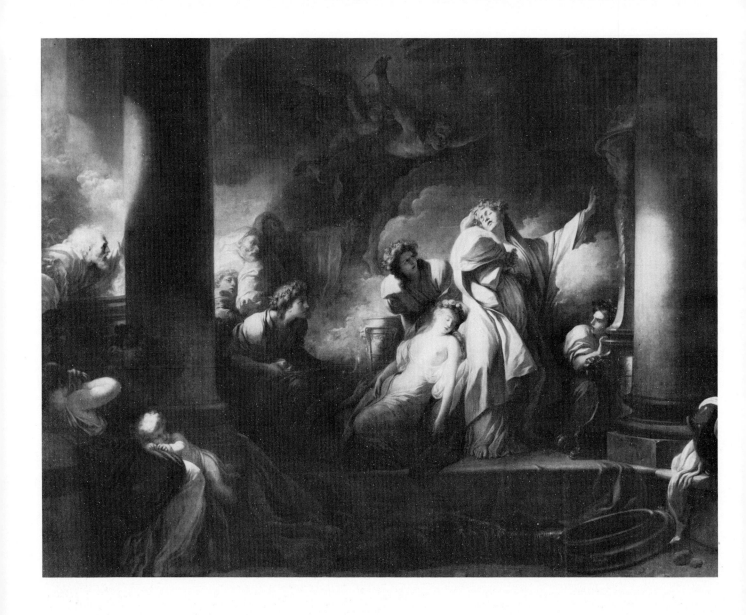

17 *Coresus Sacrificing Himself to Save Callirhoe*
PARIS, Musée du Louvre. Oil on canvas 309 × 406 cm.

Exhibited at the Salon of 1765, Fragonard's 'morceau de réception' won him a place in the
Academy in the same year. The painting was commissioned by Marigny, the Directeur des
Bâtiments, who also promised to have the work reproduced in tapestry by the Gobelins factory,
work which was never carried out. The *Coresus* was a great success with all the critics of the Salon,
including Cochin, Diderot and Fréron, but because the royal finances were precarious at this time
Fragonard was poorly paid and only belatedly, in three successive instalments in 1765, 1766 and
1773. This experience of royal patronage, as well as his own natural bent, may have put
Fragonard off further attempts at history painting. The action represented is a typical case of heroic
sacrifice popular in the second half of the eighteenth century. The Princess Callirhoe has been
designated as a victim to ward off a plague; Coresus, the high priest of Bacchus who is in love with
her, offers himself for sacrifice in her place and is about to stab himself in the chest. The
immediate source for the picture is not certain, but there are two plausible alternatives, the
tragedy by La Fosse, *Corésus et Callirhoë*, first performed in 1703, or the opera by Le Roy,
Callirhoë, first performed in 1712 and frequently later. There is no doubt about the operatic,
melodramatic character of the work, which anticipates the most extreme sadistic horrors of
Romanticism, Delacroix's *Death of Sardanapalus* for instance. Fragonard's picture was probably
intended not as an *exemplum virtutis* but as an indictment of religious fanaticism. By an ironic
accident it was criticized by the Revolutionary régime in 1793 on the grounds that it 'evoked
superstitious ideas'. There are numerous preparatory sketches for *Coresus*, and later replicas include
versions at Madrid and Angers.

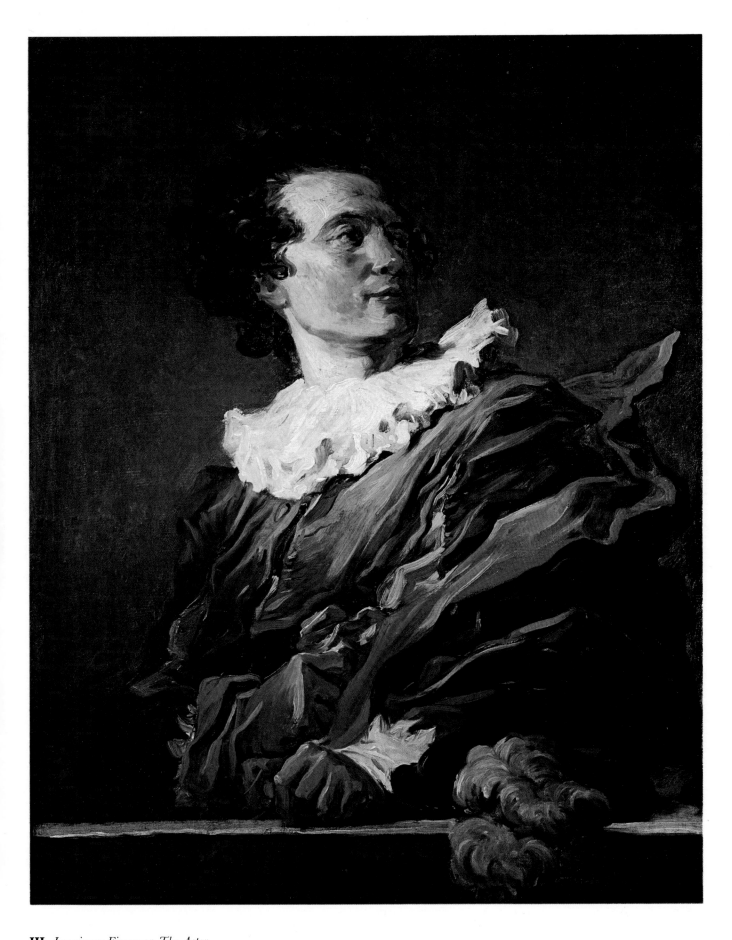

III *Imaginary Figure* or *The Actor*

PARIS, Musée du Louvre. 1769. Oil on canvas 80 × 65 cm. On the back of the picture an inscription: Portrait de l'abbé de Saint-Non, peint par Fragonard, en une heure de temps.

This is another in the series of fancy portraits showing the abbé de Saint-Non masquerading as an actor or literary hero.

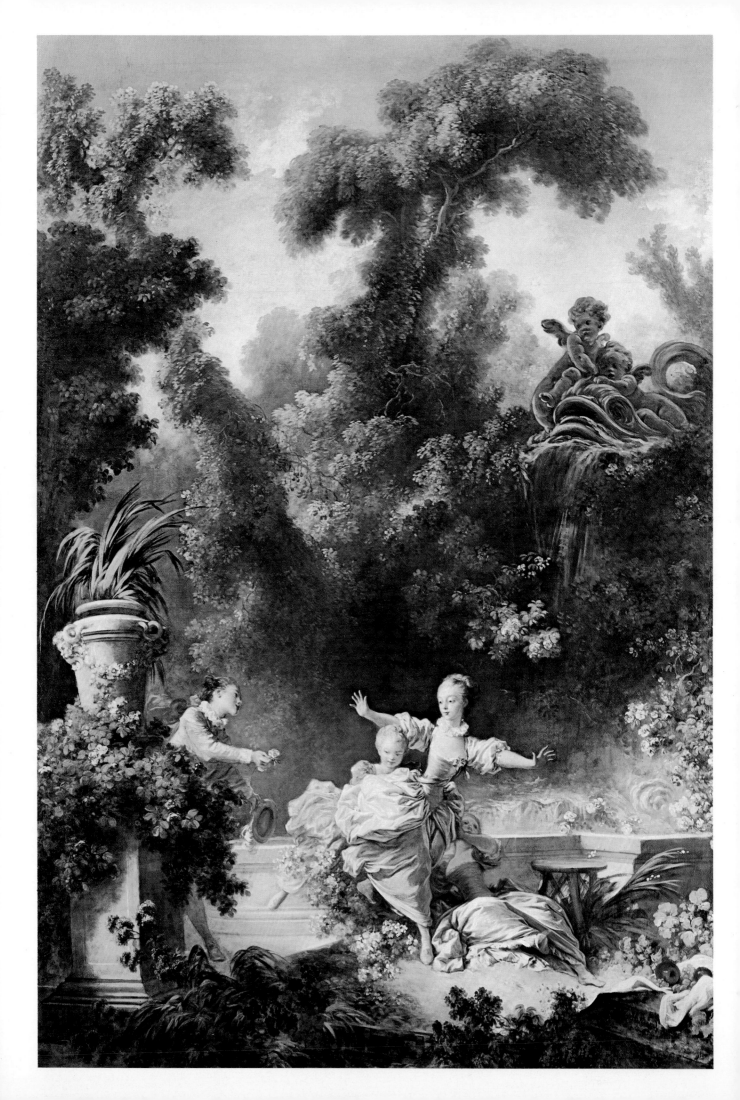

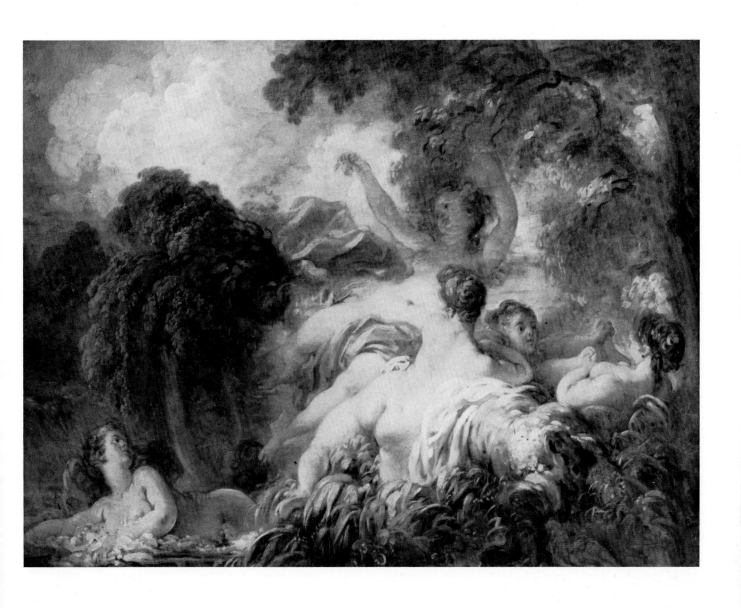

18 *The Bathers*
PARIS, Musée du Louvre. c. 1765–70. Oil on canvas 65 × 81 cm.

A whirl of naked bodies and yellow-green foliage; the unity of texture of this painting, in which water and clouds seem to be made of the same substance, make one of Fragonard's most modern compositions, a direct precursor of Renoir's *Grandes baigneuses* of 1887. The painting was in the La Caze collection and was given to the Louvre in 1869.

(*left*)
IV *The Pursuit* (Plate 34b)
NEW YORK, Frick Collection

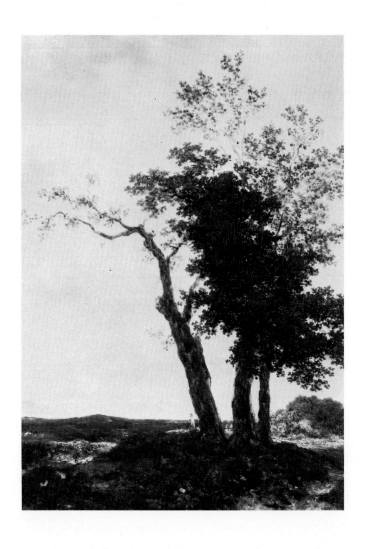

(*above*)
19 *The Three Trees*
formerly PARIS, collection of M. Cailleux. c. 1762–65. Oil on canvas 34 × 24 cm.

This most haunting of a series of landscapes in the Northern manner appeared in the Walferdin sale, April 1880. It is strongly reminiscent of Ruysdael, with brooding skies and melancholy trees, and the question has been raised whether Fragonard visited Holland, although there is no conclusive evidence to show that he did. It is certain, however, that he had ample opportunity to study the Dutch masters who figured prominently in Parisian collections in the eighteenth century. Fragonard perhaps wished to latch on to the new trend away from the Italian masters towards Dutch 'cabinet pictures' which became increasingly popular with collectors during the century. See the article by J. Wilhelm, 'Fragonard as a Painter of Realistic Landscapes', *Art Quarterly*, Autumn 1948.

(*opposite, top*)
20 *Landscape with a Large Stretch of Greensward*
GRASSE, Musée Fragonard. c. 1762–65. Oil on canvas 63 × 91 cm.

Formerly in the Louvre, but sent to Grasse in 1887, the painting is similar in composition to *Annette and Lubin* (Plate 7), a pastoral landscape with sheep and a hillock slightly off centre.

(*opposite, bottom*)
21 *The Glade* or *Landscape with a Horseman*
DETROIT, Detroit Institute of Arts. Oil on canvas 37 × 44 cm.

Given to the Detroit Institute by Mr. and Mrs. Edgar B. Whitcomb in 1948.

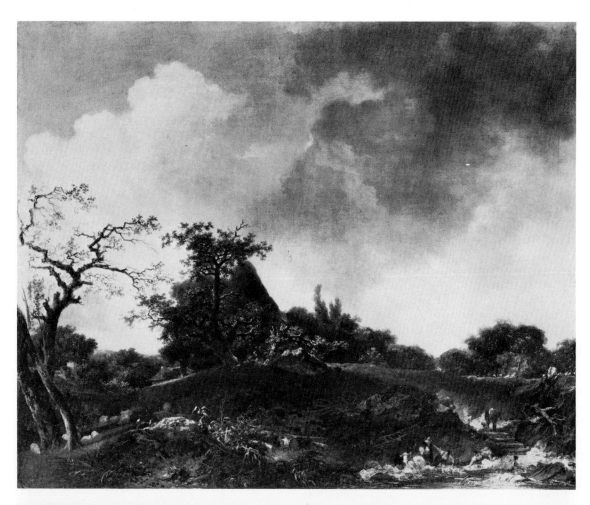

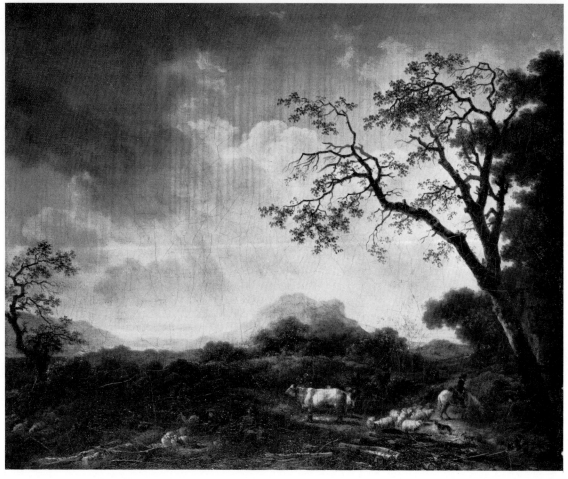

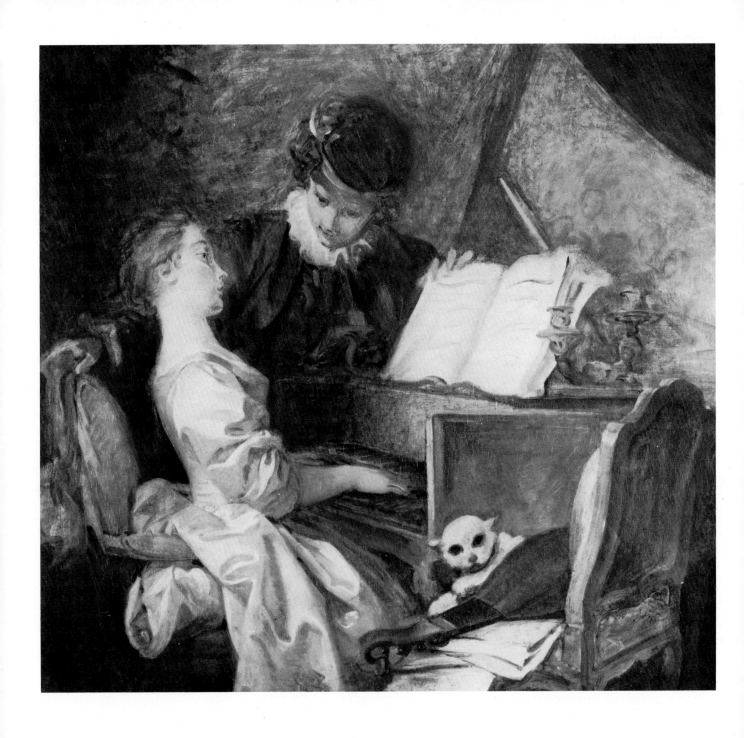

22 *The Music Lesson*

PARIS, Musée du Louvre. c. 1765–72. Oil on canvas 110 × 120 cm.

One of Fragonard's most popular paintings, and rightly so; the fond look of the boy turning over the pages and the characteristically awkward stance of the young girl practising the keyboard are perfectly observed. The spectator can almost hear the fumbling notes of a piece by Rameau or Couperin. Technically too the picture is masterly. With the shimmering satin of the girl's dress and the still-life on the right, Fragonard combined the best of both his masters, Boucher and Chardin, in this perfect evocation of domestic life in eighteenth-century France. *The Music Lesson* was in the Walferdin collection, was acquired by the French government in 1849, but was removed from the Louvre in 1865 to decorate the house of Napoleon III's private secretary. It was restored to the Louvre in 1870.

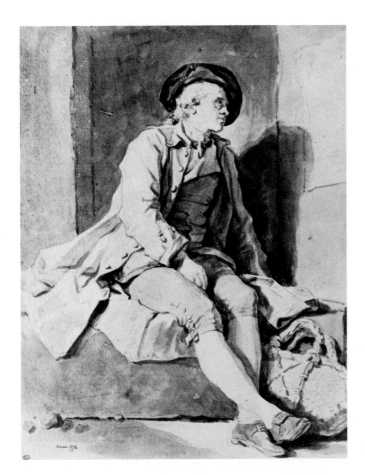

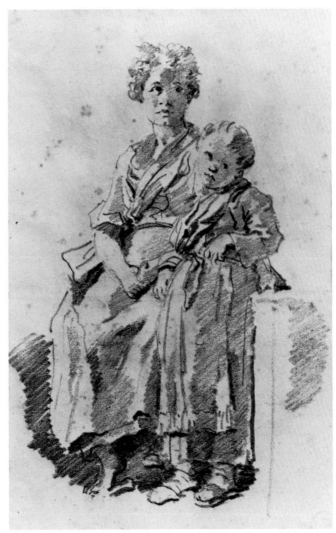

(left)
23 *Study of a Man Seated on a Stone*
PARIS, Musée de Louvre, Cabinet des Dessins. Bistre wash 36·3 × 28·6 cm. Inscribed: Rome, 1774.

This remarkable drawing shows that Fragonard's capacity for the realistic observation of ordinary people was just as strong as Chardin's or Watteau's.

(right)
24 *Young Girl and her Little Sister*
BESANÇON, Musée des Beaux-Arts. Chalk drawing on white paper 44·5 × 28·6 cm. Signed on the left: Fragonard.

Formerly in the P. A. Pâris collection, this sketch was executed in 1774, during the artist's second journey to Italy.

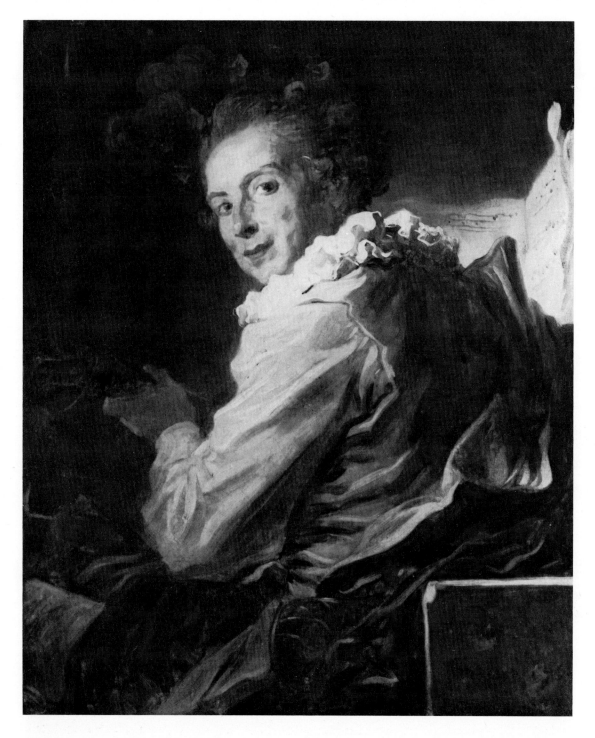

25 *Music: Portrait of M. de la Bretèche*

PARIS, Musée du Louvre. 1769. Oil on canvas 80 × 65 cm. Signed in left-hand corner: Frago 1769; on back: Portrait de la Bretèche, peint par Fragonard, en une heure de temps.

The painting passed from the La Caze collection as a gift to the Louvre in 1869. M. de la Bretèche was the brother of the abbé de Saint-Non, and this is the first and best-known of a series of about fifteen 'figures de fantaisie', or fancy portraits, all of them painted with extraordinary virtuosity, reducing the painted surface to long strands of colour. The sitters, who included Diderot and Sophie Guimard (Plate 28), all bear a family likeness, indeed they seem almost to be the same person in different disguises. There are two others of the duc d'Harcourt and the duc de Beuvron (French private collection), another known as *The Actor* (Rothschild collection), the mysterious *Warrior* (Plate 27) and *Saint-Non in Spanish Costume* (Plate 29). The remaining seven are in the Louvre, including *Song* (or *Study*), *The Actor* (Plate III) and *Inspiration* (Plate 26), which, with the portrait of *M. de la Bretèche*, may be representations of the four arts, music, drama, poetry and song. M. Thuillier has pointed out the affinity between Fragonard's portraits and Rubens's cycle of *The Life of Marie de' Medici*, especially in the style of costume and dress. Fragonard's portraits are also strongly sculptural in feeling. The artist handled paint like a sculptor modelling clay, and there is often a resemblance between his portraits, detached on their pedestals in half-profile, and busts by Houdon.

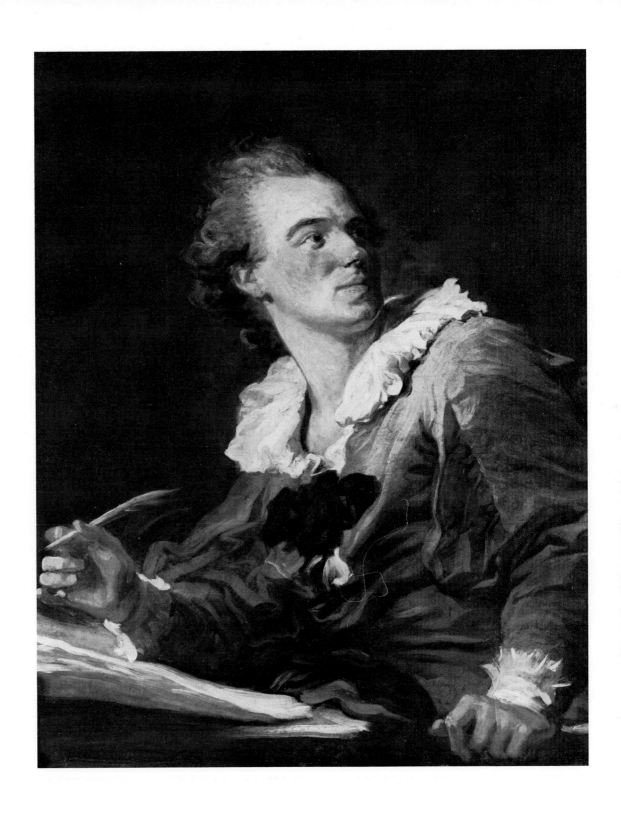

26 *Inspiration*
PARIS, Musée du Louvre. 1769. Oil on canvas 80 × 60 cm.

Another of the 'figures de fantaisie', *Inspiration* probably represents the art of poetry. The picture
has been thought to be a portrait of the abbé de Saint-Non, and the sitter undoubtedly has similar
features to the abbé on the basis of Saint-Non's portrait in Spanish costume (Plate 29). Again, the
precise identity of the subject is not of great importance, for what Fragonard created is an
impersonal depiction of the act of literary creation.

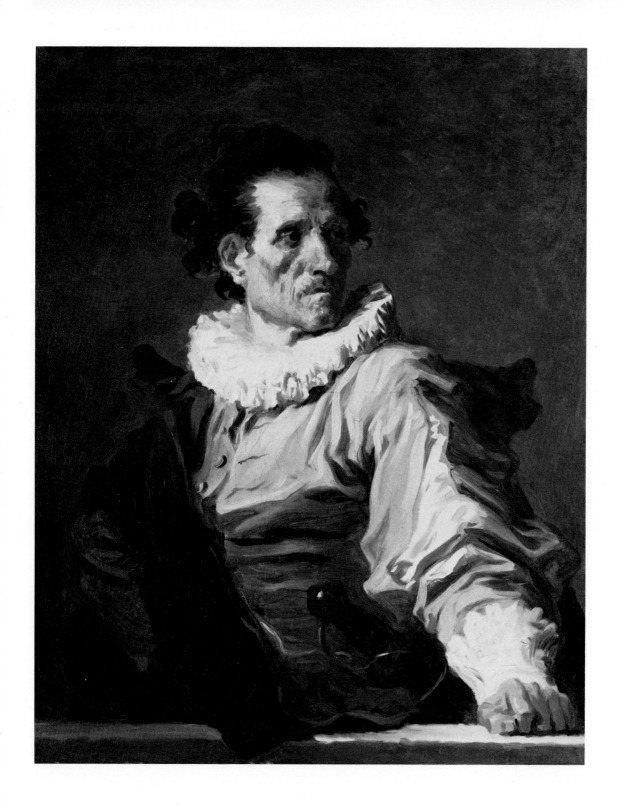

27 *The Warrior*

WILLIAMSTOWN, Sterling and Francine Clark Art Institute. c. 1770–73. Oil on canvas 81 × 65 cm.

Bought in 1774 by Stanislas Poniatowski, King of Poland, *The Warrior* then belonged to Count Potocki and was recently acquired by the Sterling and Francine Clark Institute (See C. Sterling, *An Unknown Masterpiece by Fragonard*. Special publication of the Clark Institute, 1964). It is one of the most striking and still least known of Fragonard's portraits. The sitter is wearing a bright yellow tunic, white ruff and black cape lined with red, with the handle of his sword thrust aggressively forward. Whoever he is, and his identity is unknown, this mysterious figure has the hard-bitten, deeply cut features of some heroic desperado with something of the stoical disillusionment present in Daumier's portraits.

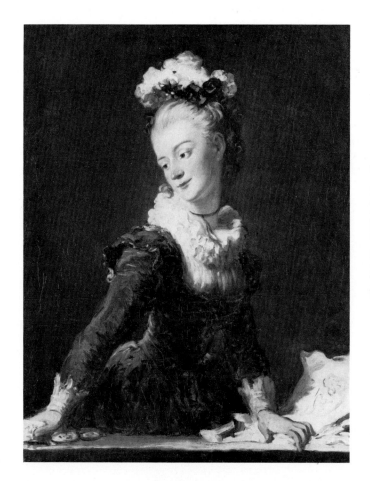

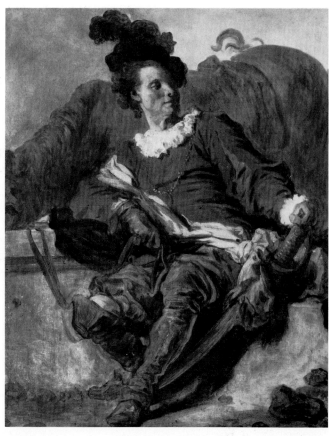

(left)
28 *Portrait of Sophie Guimard*
PARIS, Musée du Louvre. c. 1770. Oil on canvas 81 × 64 cm.

Formerly in the Watel-Dehaynin collection, the painting was acquired by the Louvre in 1972. The sitter is probably the ballet dancer, Mlle. Guimard. Since Fragonard is known to have worked for her between 1770 and 1773 this portrait probably dates from those years; it is also clearly related in style to the fancy portraits in the Louvre of the same period. The colour scheme of this picture was a favourite one with Fragonard in his maturity, a brown ground with a few streaks of red, contrasted with the white sleeves, ruff and head-dress.

(right)
29 *The abbé de Saint-Non in Spanish Costume*
BARCELONA, Museum of Modern Art. Oil on canvas 94 × 74 cm.

Another of the 'figures de fantaisie' painted in or around 1769, this portrait depicts the abbé de Saint-Non dressed up in a red tunic, white ruff and black plumed hat, holding a huge sword in one hand and, in the other, the reins of his horse tethered behind him. The most likely explanation is that Saint-Non is masquerading as Don Quixote. Fragonard is known to have planned a series of illustrations for Cervantes's novel (Plates 48a, b).

45

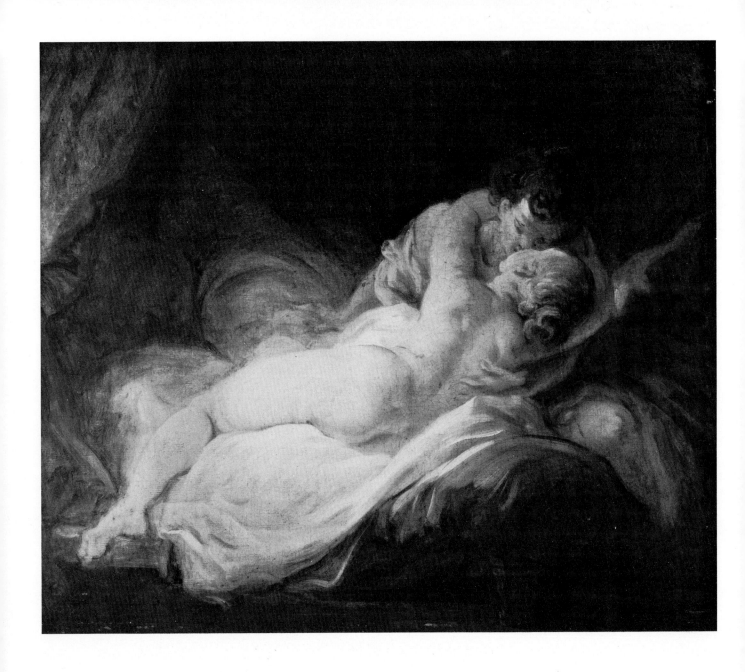

(*above*)
30 *The Longed-for Moment* or *The Happy Lovers*
PARIS, collection of M. Arthur Veil-Picard. 1765–70. Oil on canvas 55 × 65 cm.

The Longed-for Moment appeared in the Walferdin sale, 1880. In the appendix to their study of Fragonard (1865) the Goncourts reported that at 'M. Walferdin's house there were some of the Master's finest pictures; a young man kissing a woman lying on a bed. . . .'

(*opposite, top*)
31 *The Stolen Shirt*
PARIS, Musée du Louvre. c. 1765–72. Oil on oval canvas 36 × 43 cm.

Originally in the La Caze collection, *The Stolen Shirt* was given to the Louvre in 1869. It is the pendant to *All Ablaze* (Plate 32) and was sketched by Gabriel de Saint-Aubin in the margin of the Gros sale catalogue of 1778. One of the artist's most accomplished erotic pieces, it is as neat and deft as the action of the cupid, shown undressing the girl on the bed.

(*opposite, bottom*)
32 *All Ablaze* or *Le Feu aux poudres*
PARIS, Musée du Louvre. c. 1765–72. Oil on oval canvas 37 × 43 cm.

As with its pendant (Plate 31), *All Ablaze* was sketched by Saint-Aubin in the margin of the Gros sale catalogue of 1778. Here the cupid is seen setting the girl ablaze with passion with his torch.

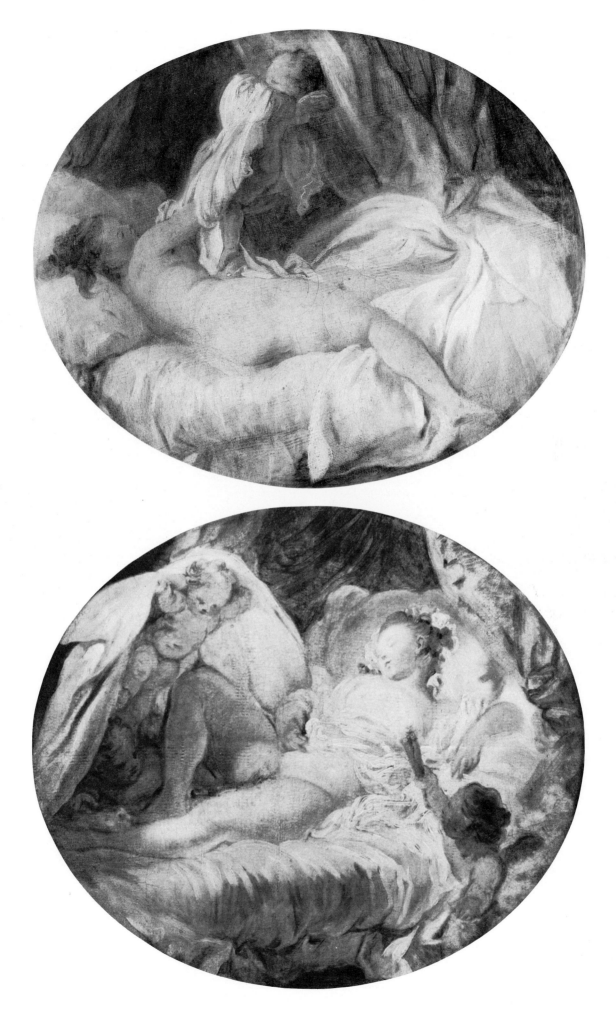

33 *The Bed with Cupids*
BESANÇON, Musée des Beaux-Arts. Pen and ink wash with watercolour on white paper 45·7 × 30·4 cm. On the left, at the bottom, in Pâris's hand: Fragonard.

Collections: P. A. Pâris; Bibliothèque Municipale de Besançon.

34 *The Pursuit of Love*
NEW YORK, Frick Collection. 1770–72.

Storming the Citadel. Oil on canvas 318 × 224 cm.

The Pursuit. Oil on canvas 318 × 215 cm.

The Declaration of Love. Oil on canvas 318 × 215 cm.

The Lover Crowned. Oil on canvas 318 × 243 cm.

Abandonment (oil on canvas 318 × 196 cm.), the fifth panel, may also belong to the series but was probably painted later, around 1790, to decorate the dining room of Fragonard's cousin Maubert at Grasse.

The series of decorative panels known as *The Pursuit of Love* was originally commissioned, probably in 1770, by Mme. du Barry for her new pavilion at Louveciennes. The original château at Louveciennes was a modest affair and had been given to Mme. du Barry in July 1769. In 1770 she ordered the architect Ledoux to build her a new house in the latest Neo-Classical style, with a severe façade and recessed Ionic columns. This was the building for which Fragonard's panels were intended, and he probably started work in the autumn of 1771. On 22 July 1772 Bachaumont reported in his *Mémoires secrets* that 'the curious are going in large numbers to Louveciennes to see the pavilion of Madame du Barry; but not everyone who wants can enter, and it is only by a special favour that one can penetrate this sanctuary of pleasure.' Then in 1773, for unstated reasons, she returned Fragonard's panels and paid him 18,000 livres compensation. She replaced his work with paintings by Joseph-Marie Vien, whose pseudo-Greek style had become fashionable in smart society. The reason for Mme. du Barry's sudden change of mind has recently been most satisfactorily explained in an article by F. M. Biebel (*Gazette des Beaux-Arts*, October 1960), namely that Fragonard's Rococo style was already considered out of date by the court circle who preferred the attenuated Greek style of Vien. Thus Fragonard was overtaken by the rapidly changing taste of late eighteenth-century France. After the rejection of his panels Fragonard rolled them up, put them in store and in 1790 took them to Grasse, where he used them to decorate his cousin's house. He also painted other panels there of similar size and theme, including, probably, the *Abandonment*. In 1806 Malvilan, who then owned the house, offered to sell them to Fragonard's son Alexandre-Evariste; he declined the offer. In 1857 they were offered to the Louvre, which, for lack of funds, was unable to buy them. Finally in 1898 Malvilan's heirs sold the canvases to Wertheimer in London, who sold them to Pierpont Morgan. They were acquired by Frick in 1915.

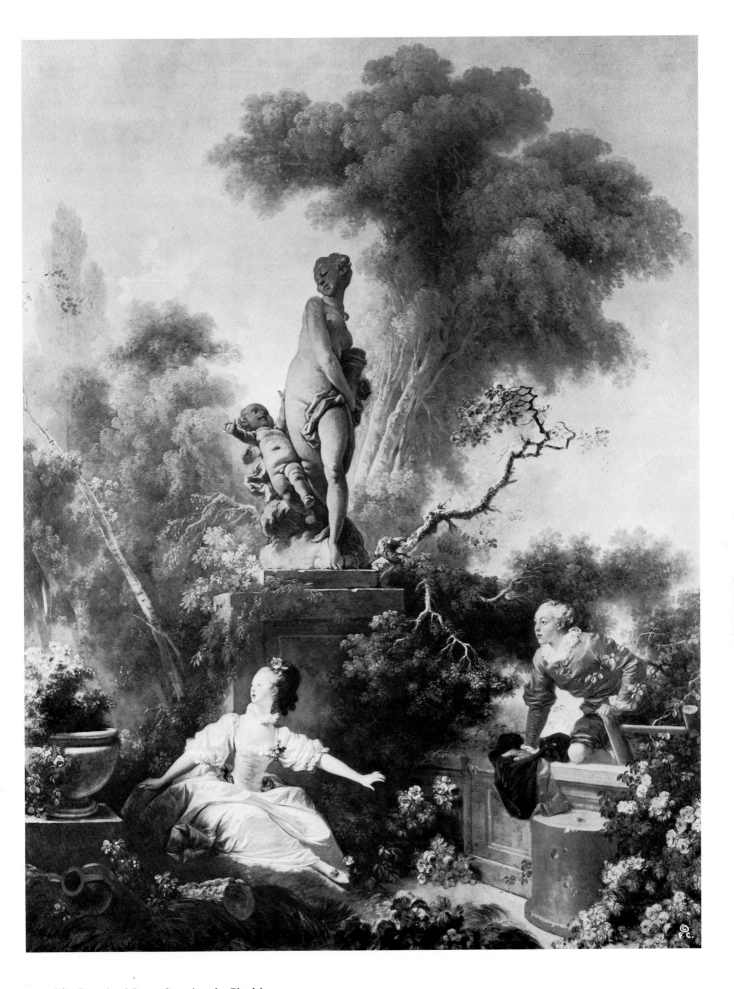

34a *The Pursuit of Love: Storming the Citadel*

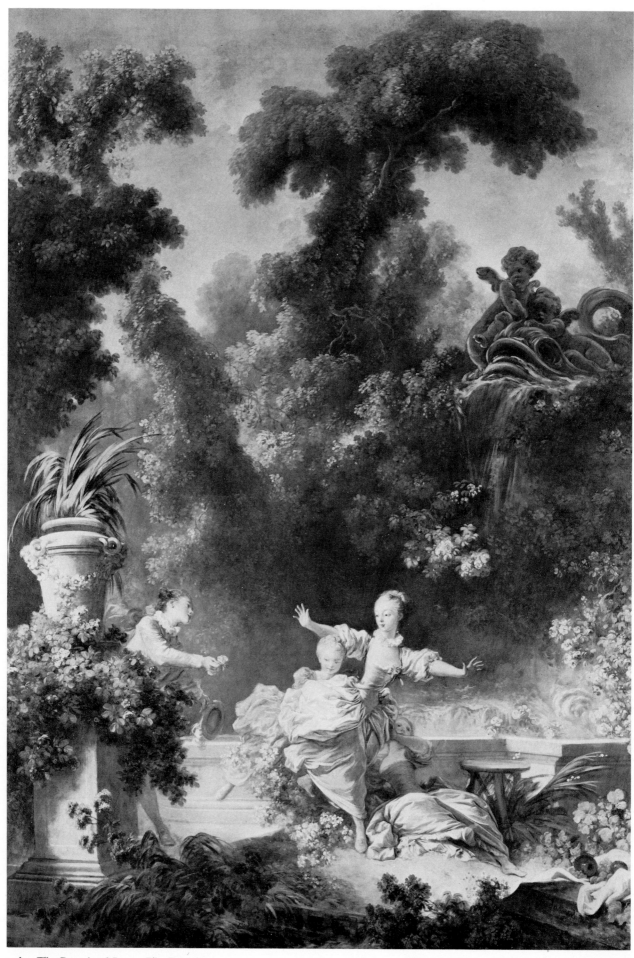

34b *The Pursuit of Love: The Pursuit*

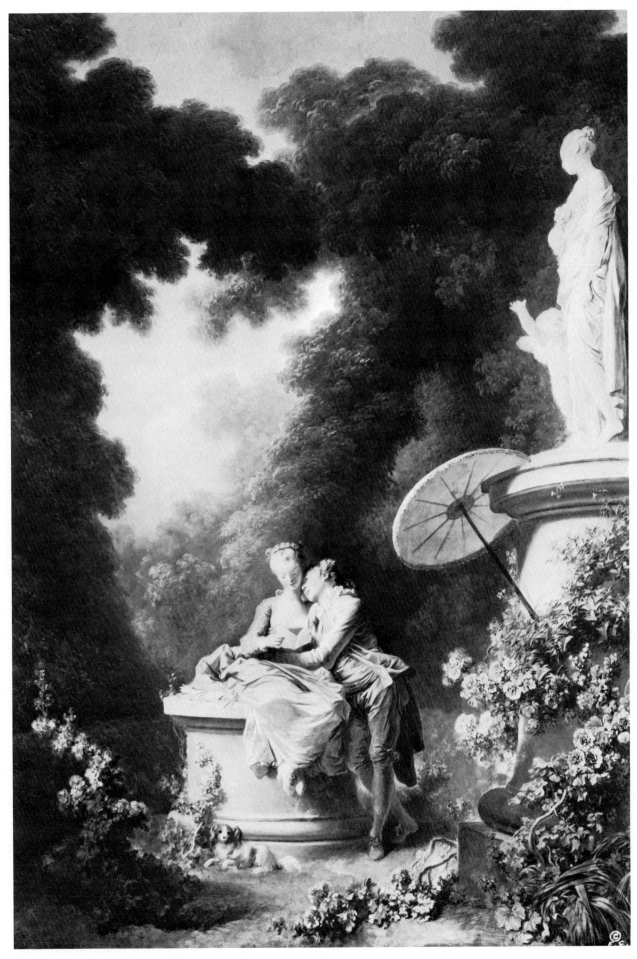

34c *The Pursuit of Love: The Declaration of Love*

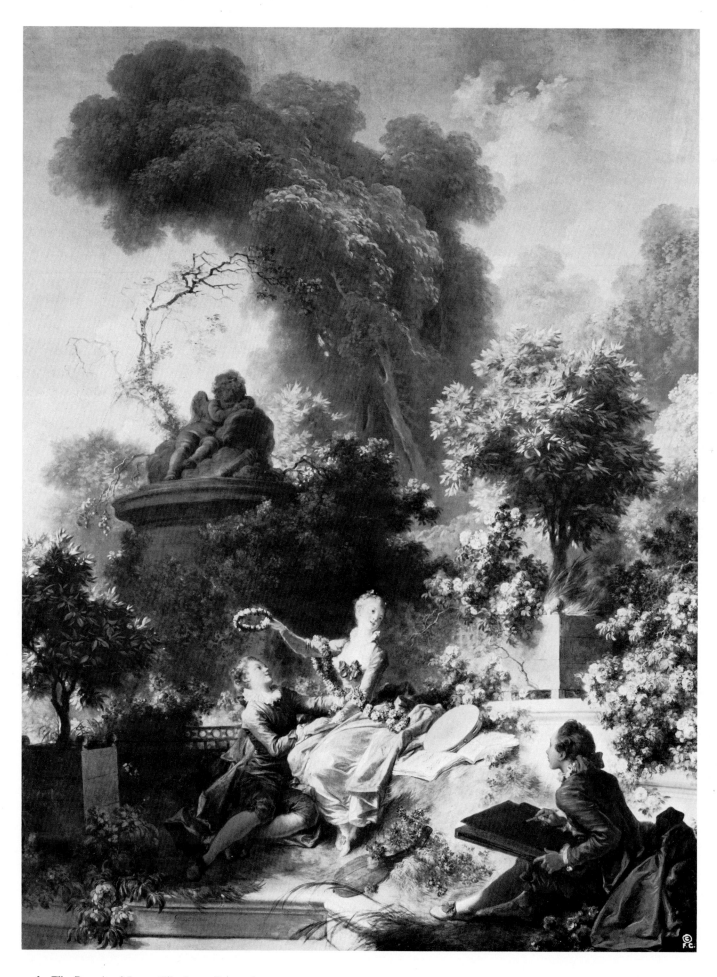

34d *The Pursuit of Love: The Lover Crowned*

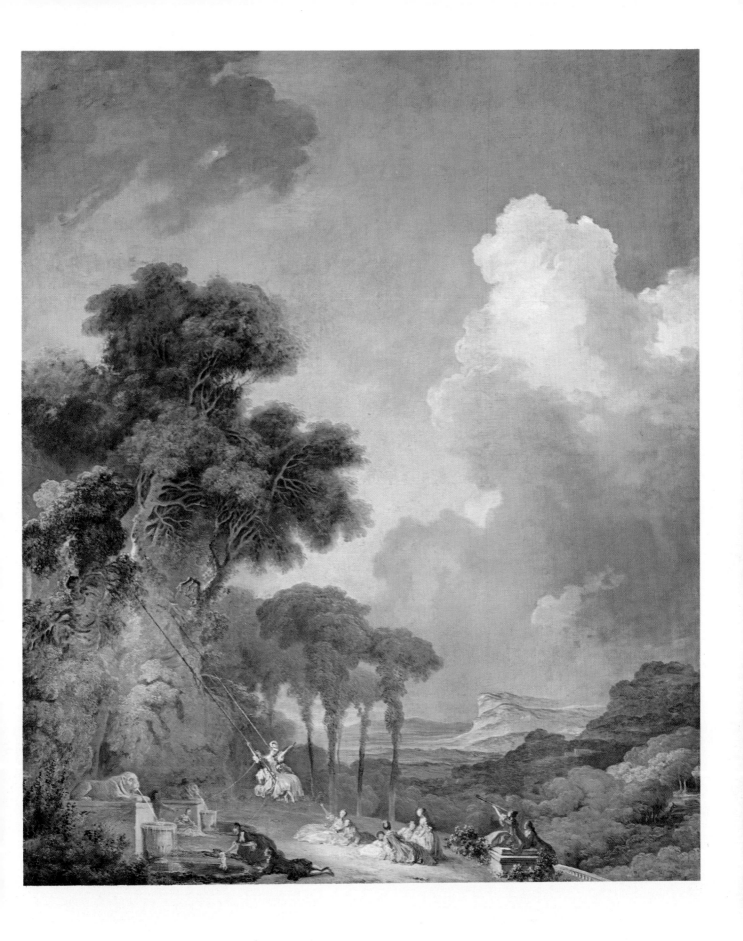

V *The Swing* (Plate 36)
WASHINGTON, National Gallery of Art (Samuel H. Kress collection)

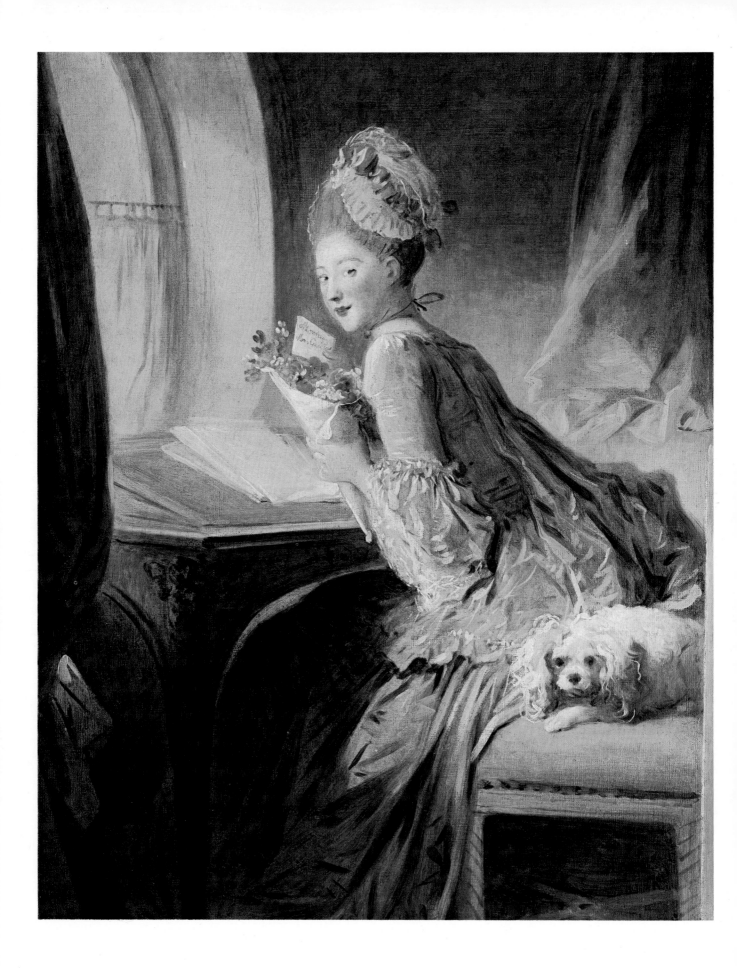

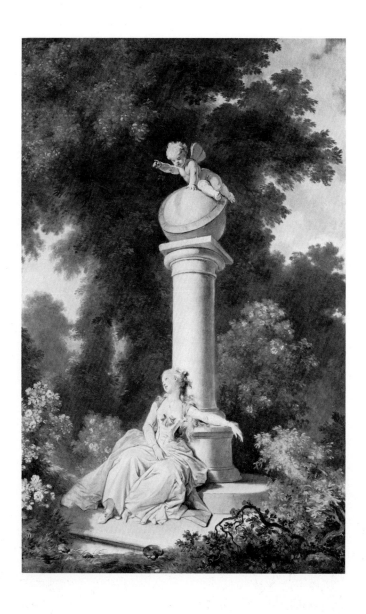

(left)
VI *The Love Letter* or *Le Billet Doux*
NEW YORK, Metropolitan Museum of Art (Jules S. Bache collection). c. 1775. Oil on canvas 83 × 67 cm.

Formerly in the Feuillet de Conches collection, *The Love Letter* is one of Fragonard's most bewitching studies of women. The sitter is tall and slender, with an oval-shaped face, unlike some of his nudes who tend to be chubby and featureless. She is sitting at a desk, half-turned towards the spectator, clasping a bunch of flowers with a love message which cannot be deciphered with certainty. The exact wording of the message is less important than Fragonard's exceptional ability to portray the state of emotional anticipation in a woman. When André Gide saw this painting at an exhibition of the Crosnier collection in 1905 he found it 'delightful' but considered Fragonard's reputation to be exaggerated (Gide, *Journal*, ed. Pléiade, p. 186).

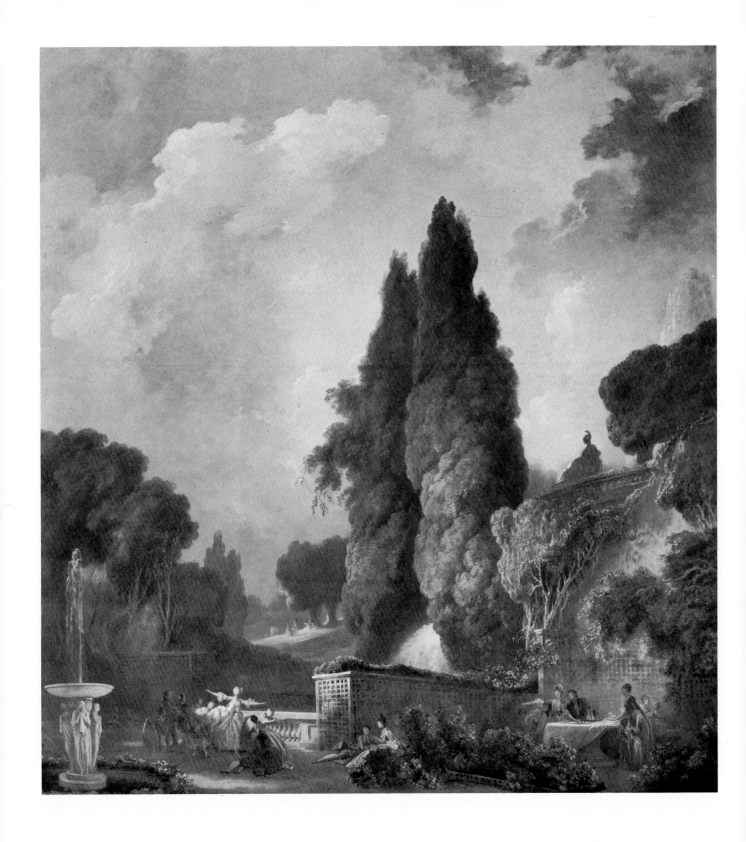

35 *Blind Man's Buff*
WASHINGTON, National Gallery of Art (Samuel H. Kress collection). c. 1775. Oil on canvas
215 × 197 cm.

The pendant to *The Swing* (Plate 36) and one of the great decorative panels related to *The Fête at Saint-Cloud* and *The Fête at Rambouillet, Blind Man's Buff* was painted probably soon after Fragonard's return from his second journey to Italy in 1774. This and the other Washington picture were probably in the collection of Saint-Non, catalogued as 'Un paysage fait en Italie avec figures, sujet de la Main Chaude'. As in all the works of Fragonard's maturity, his treatment of the landscape, whether actually in France or in Italy, is unmistakably Italianate, with tall cypresses, fountains and statues. On the left a small group of young people is playing blind man's buff, while on the right others are preparing a picnic. The whole work has something of the atmosphere of a Venetian carnival seen by Tiepolo.

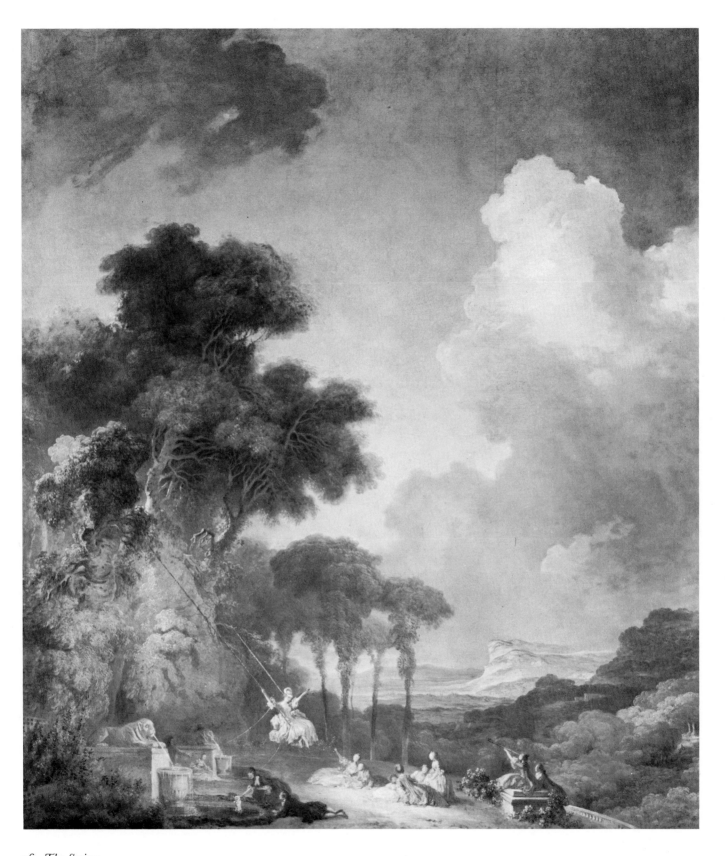

36 *The Swing*
WASHINGTON, National Gallery of Art (Samuel H. Kress collection). c. 1775. Oil on canvas 215 × 186 cm.

The pendant to *Blind Man's Buff*, *The Swing* may be the painting mentioned in the 1791 inventory of the collection of the abbé de Saint-Non as a 'Paysage d'Italie par Fragonard avec figures, sujet d'une balançoire'. One of Fragonard's most beautiful creations, the scene is set, perhaps, in a royal park just outside Paris, although the peculiar shape of the mountain in the distance suggests a more exotic Mediterranean landscape. Like Watteau, Fragonard had a fine feeling for the grouping of figures, and the couple on the park bench, especially the woman looking through the telescope, is one of the most perfect details in his work.

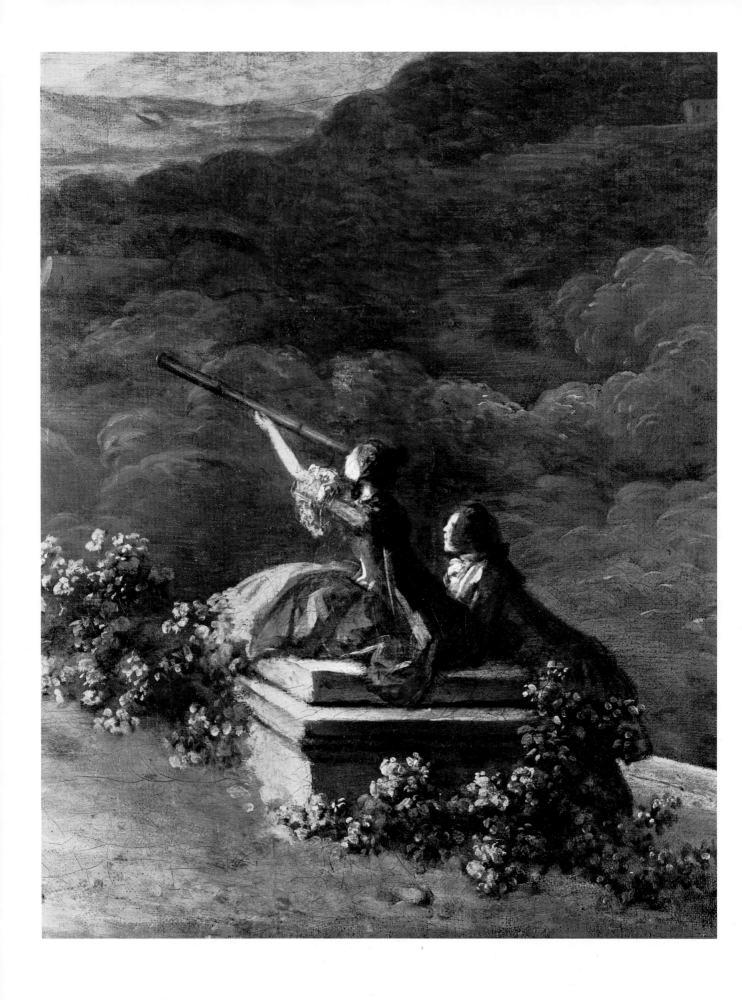

36a *The Swing* (detail)

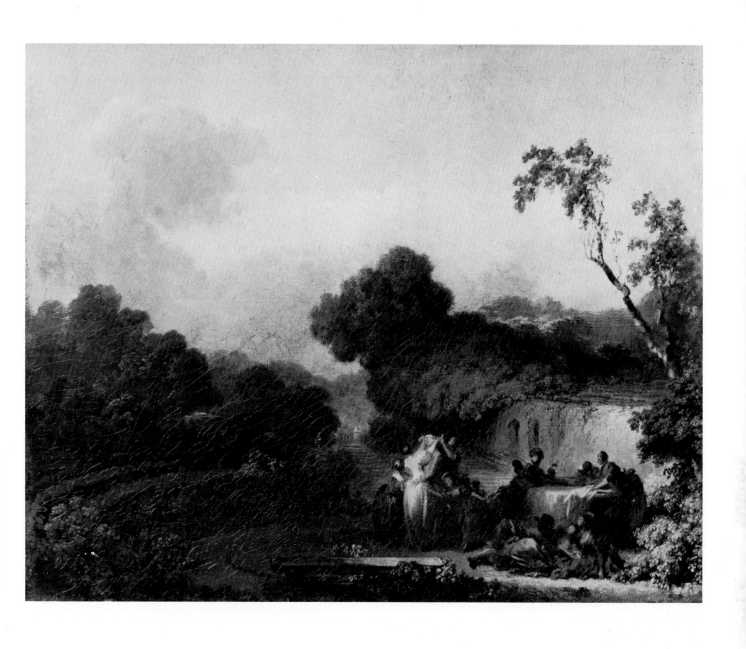

37 *Blind Man's Buff*

PARIS, Musée du Louvre. c. 1775. Oil on canvas 36 × 45 cm.

Acquired by the Louvre in 1926 from M. Alexandre Poliakoff, this version of *Blind Man's Buff* was
mentioned in the catalogue of the Gros sale in 1778 with its description as 'A landscape of a fresh,
rustic kind set in the neighbourhood of Meudon. In the foreground and on a terrace one can see
several groups of girls and boys, some of whom are preparing to play blind man's buff and others,
next to a table, are busy with different kinds of games.' Underneath this caption is a sketch by
Gabriel de Saint-Aubin. This painting is perhaps the one in which Fragonard came closest in
spirit to Watteau.

38 *Landscape with Two Figures*
BARNARD CASTLE, Bowes Museum. c. 1770–75. Oil on canvas 27 × 20 cm.

This tiny, little-known landscape shows Fragonard in a mood clearly influenced by Watteau. Related in style to the Washington *Swing* and *Blind Man's Buff* and probably dating from the 1770s, it appeared in Agnew's exhibition (1952) of pictures from the Bowes Museum (no. 45) and at the Royal Academy in the 1954 European Masters of the Eighteenth Century exhibition (no. 204).

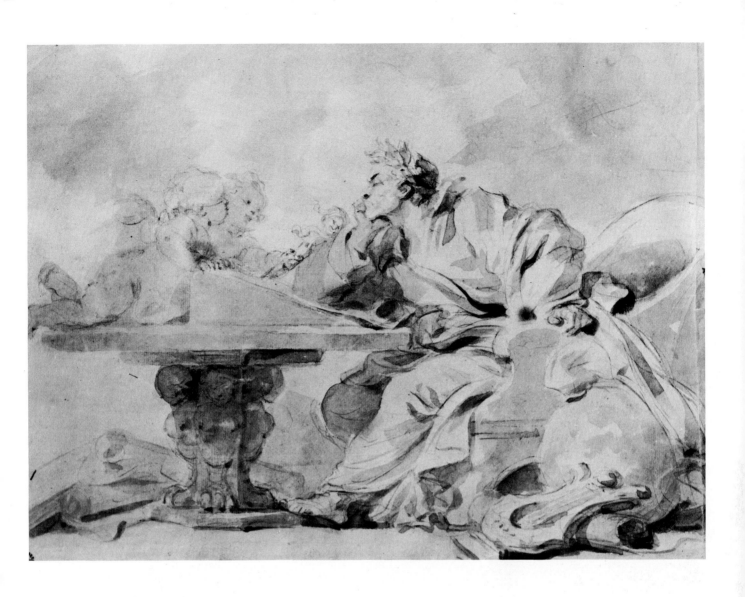

39 *Illustrations for Ariosto's 'Orlando Furioso'*

Many of these were published in the volume *Fragonard: Drawings for Ariosto* (London, 1946), with essays by Elizabeth Mongan, Philip Hofer and Jean Seznec. It contains 137 drawings by Fragonard for an edition of the *Orlando Furioso* which never appeared. Their first owner was Hippolyte Walferdin and they were bought at his sale in 1880 by Louis Roederer. The illustrations were dispersed in 1923 and are now scattered in various collections in America, Paris and Berlin. About 150 drawings for Ariosto are now known to exist, and others may be in circulation. All the drawings in this series correspond closely to specific episodes in Ariosto's epic poem. Although Fragonard displays abundant verve and creative power, sometimes bordering on the fantastic, he sticks closely to the text. In fact, as Jean Seznec remarks, the natural affinity between Fragonard and Ariosto and their common Mediterranean heritage made the one the ideal interpreter of the other. These wonderfully sparse and luminous drawings have all the clarity of a poetic image; those reproduced (Plates 39b–f) have been grouped to illustrate the episode of Roger freeing Angelica, a theme which also held a strong appeal for Ingres and the Romantics.

39a *Ariosto Inspired by Love and Folly*
BESANÇON, Musée des Beaux-Arts. Bistre wash on black chalk 3·3 × 4·5 cm.

Formerly in the collection of Pierre-Adrien Pâris, the drawing entered the Musée des Beaux-Arts, Besançon, in 1843. Possibly intended as the frontispiece for the edition of *Orlando Furioso*, it shows Ariosto composing his poem under the twin inspiration of Love and Folly.

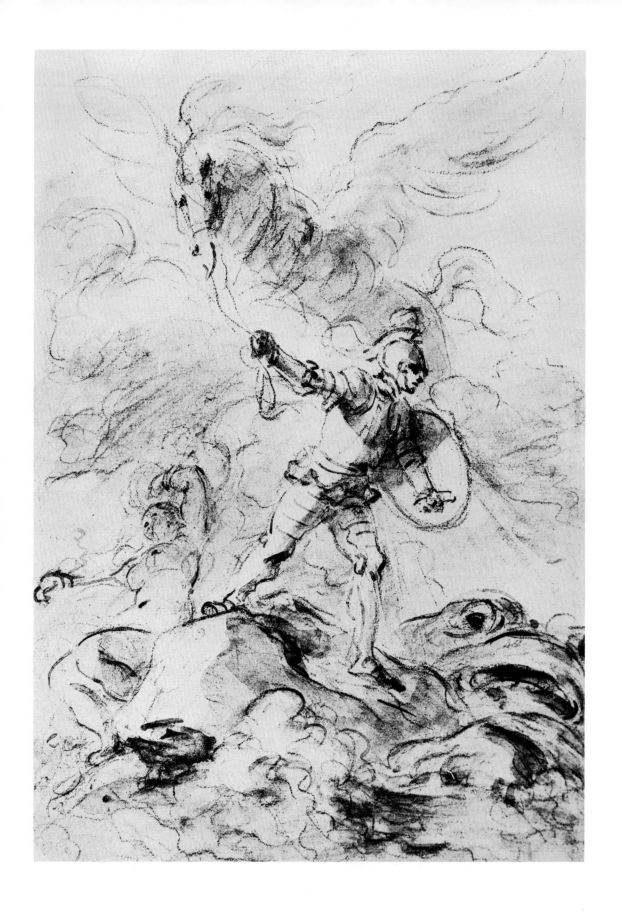

39b *Ruggiero Blinds the Orc*
formerly PHILADELPHIA, collection of A. S. W. Rosenbach. Black chalk and bistre wash.

From Canto X of *Orlando Furioso*.

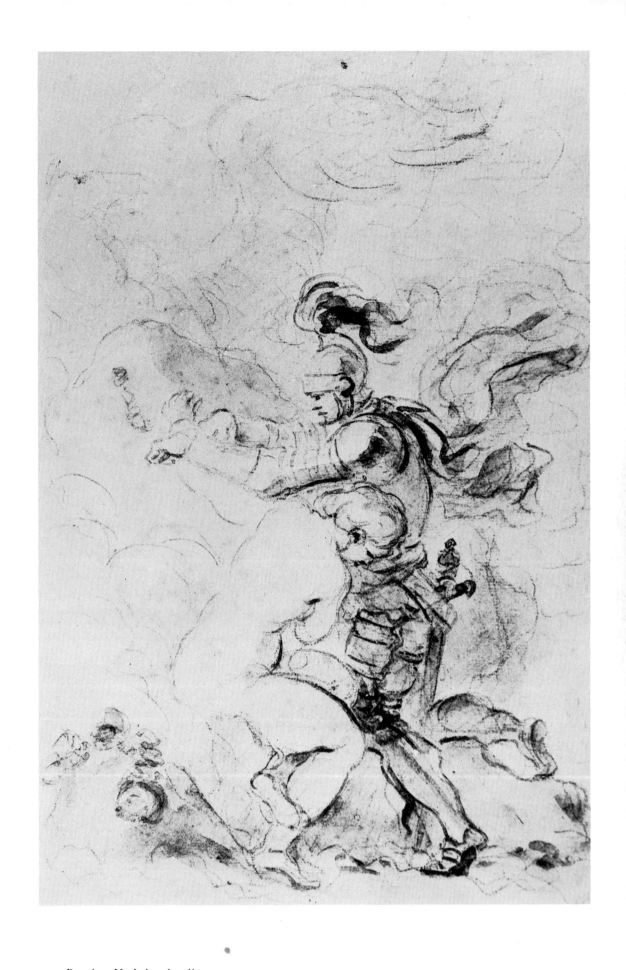

39c *Ruggiero Unchains Angelica*
formerly PHILADELPHIA, collection of A. S. W. Rosenbach. Black chalk and bistre wash.

From Canto X of *Orlando Furioso*.

39d *Ruggiero Divests Himself of his Armour*
PHILADELPHIA, the Rosenbach Foundation. Black chalk and bistre wash.

From Cantos X and XI of *Orlando Furioso*.

39e *Ruggiero Seeks Angelica who Has Made Herself Invisible*
formerly PHILADELPHIA, collection of A. S. W. Rosenbach. Black chalk and bistre wash.

From Canto XI of *Orlando Furioso*.

39f *Ruggiero Despairs at the Loss of Angelica*
PHILADELPHIA, the Rosenbach Foundation. Black chalk and bistre wash.

From Canto XI of *Orlando Furioso*.

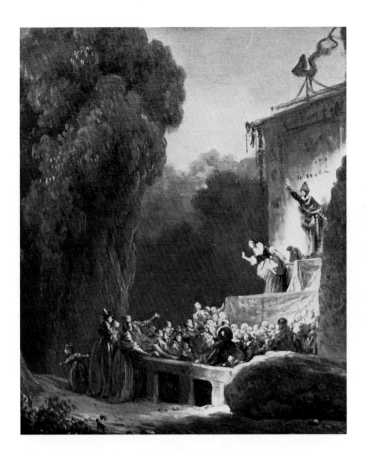 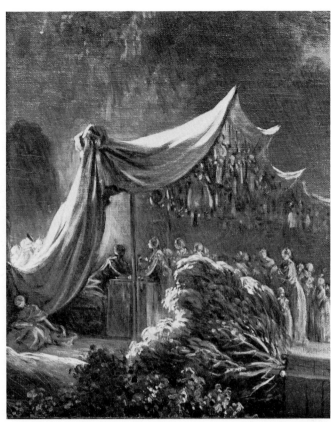

(*left*)
40 *The Charlatans*
ZÜRICH, collection of Emile Bührle. c. 1770–75. Oil on canvas 49 × 38 cm.

A study for the left hand part of *The Fête at Saint-Cloud* (Plate 42), this large sketch differs from the final version in that the figure on the rostrum in front of the placard is holding a sword and wears a red cap. He is probably one of the figures from the Commedia dell'Arte. The beribboned placard seems to be a kind of programme of events illustrated by a strip cartoon round the border. Whether actor, quack-doctor or simple mountebank, his function is to entertain the crowd thronged around the stall. This was just one of the amusements provided for the Parisian people.

(*right*)
41 *The Toy Seller*
ZÜRICH, collection of Emile Bührle. c. 1770–75. Oil on canvas 40 × 33 cm.

This is a study for the central part of *The Fête at Saint-Cloud*. The toys for sale can be seen hanging from the roof of the booth, glowing with luminous colour.

(*overleaf*)
42 *The Fête at Saint-Cloud*
PARIS, Banque de France. Oil on canvas 216 × 335 cm.

Probably painted in 1775 for the duc de Penthièvre to decorate his apartment in the Hôtel de Toulouse, since 1808 the Banque de France, *The Fête at Saint-Cloud* now hangs in the Governor's dining room, which it has rarely left. It was recently exhibited in Paris in 1975. See G. Wildenstein, 'La Fête de Saint-Cloud et Fragonard', *Gazette des Beaux-Arts*, January 1960.

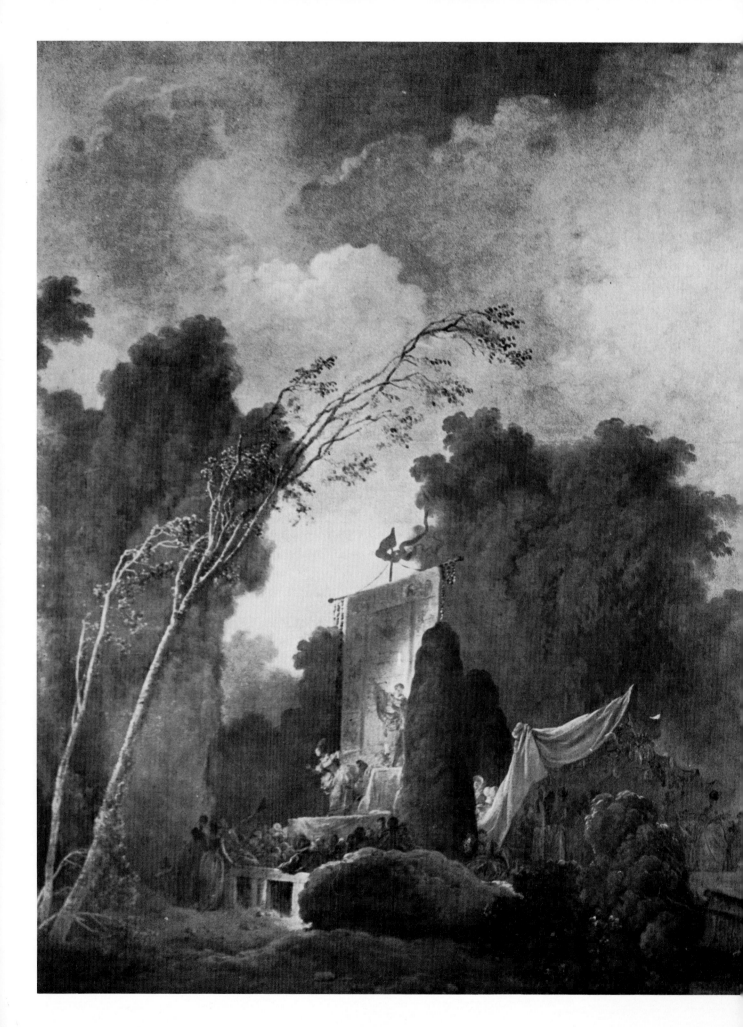

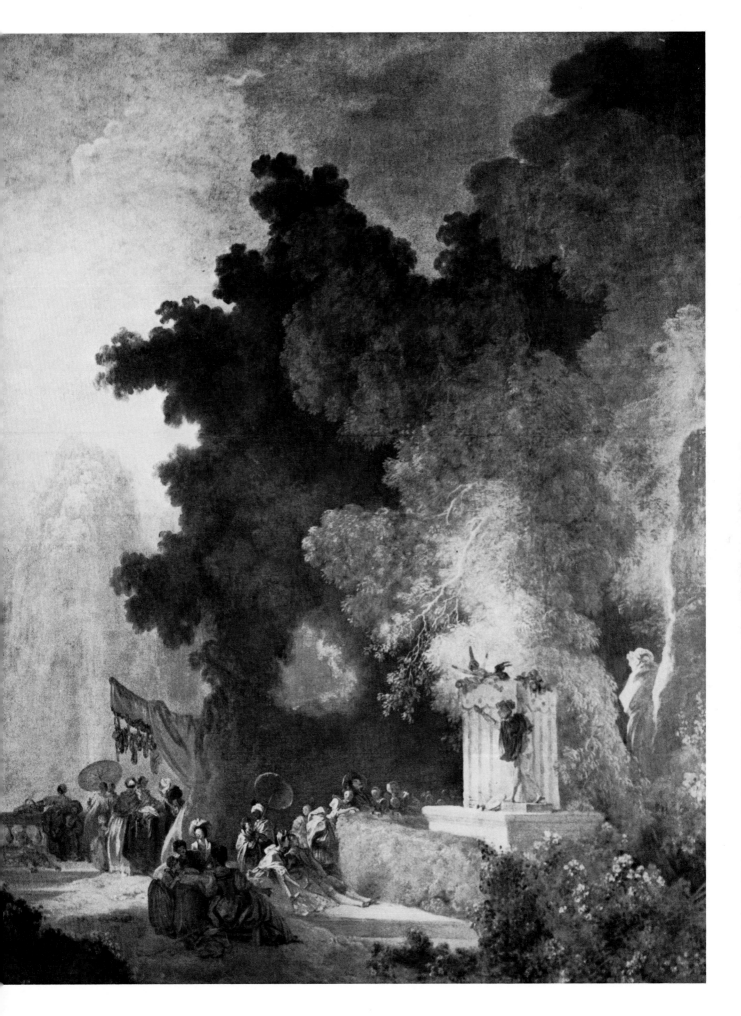

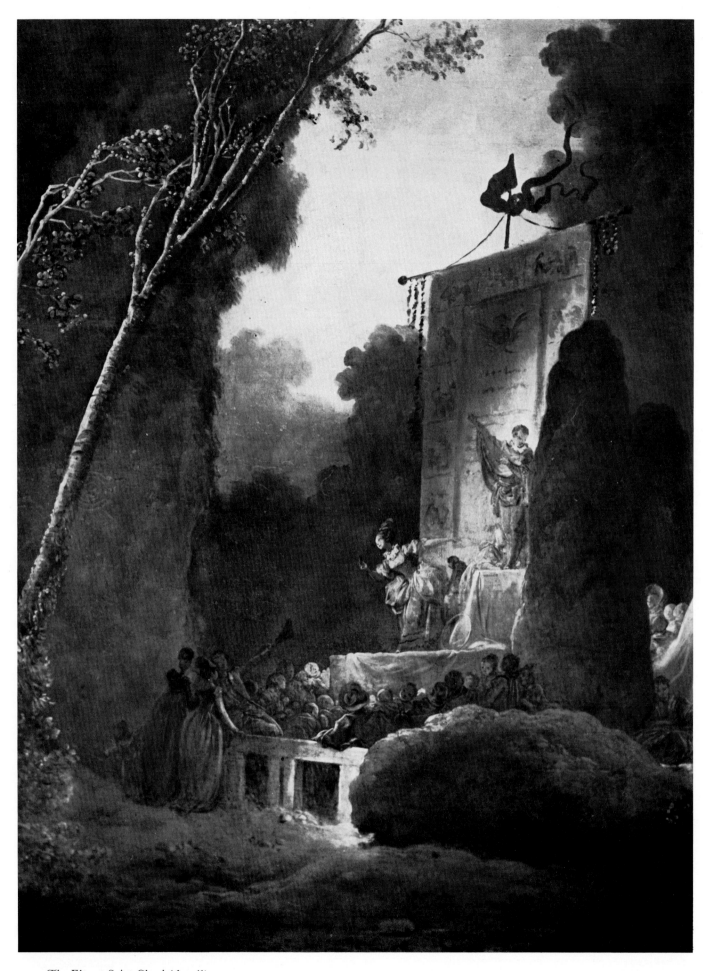

42a *The Fête at Saint-Cloud* (detail)

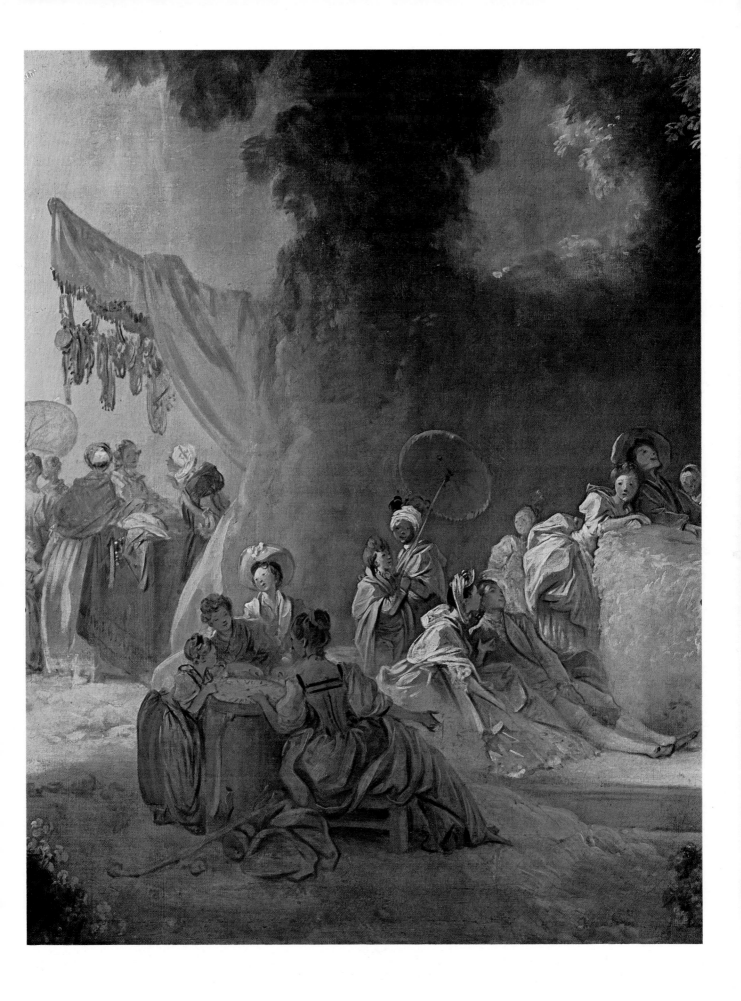

VII *The Fête at Saint-Cloud* (detail)

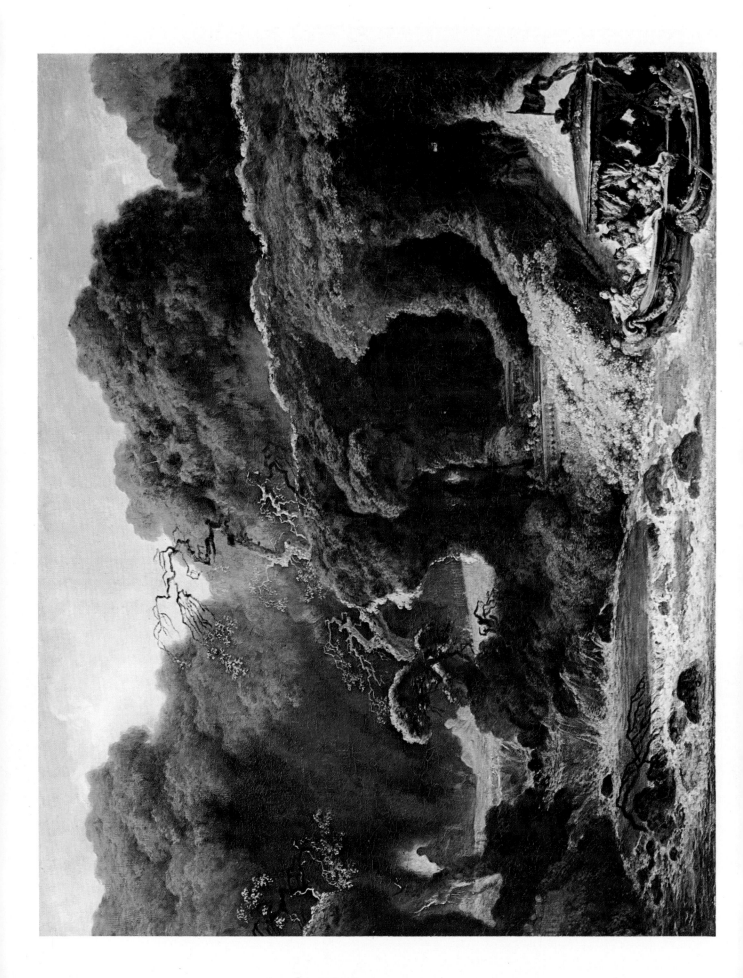

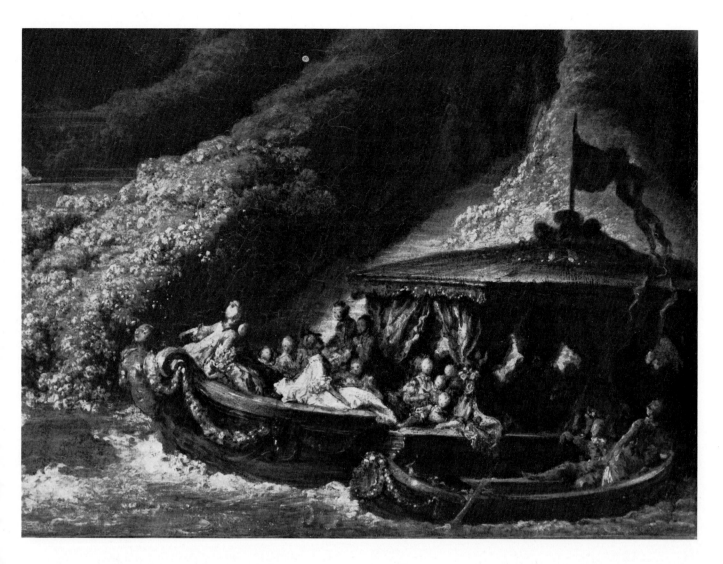

43 *The Fête at Rambouillet* (detail of Plate VIII)

(left)
VIII *The Fête at Rambouillet* or *The Island of Love*
LISBON, Calouste Gulbenkian Foundation. c. 1775. Oil on canvas 72 × 91 cm.

Exhibited at the Salon de la Correspondance in 1782 under the title 'Une grotte ornée
d'architectures avec figures', *The Fête at Rambouillet* is another key work in Fragonard's oeuvre and
one which poses several problems. First, the dating. A stylistic comparison with *The Fête at
Saint-Cloud* would indicate that it was painted around 1775. The setting is almost certainly the
Island of Rocks in the park of the Château de Rambouillet, which then belonged to the duc de
Penthièvre; it is reasonable to suppose that it was he who commissioned the painting. The subject
is not altogether plain, but it may be one of the parties held in honour of Louis XV's frequent
visits to Rambouillet. The painting seems like a remote echo of Watteau's *Embarkation for Cythera*,
some refined form of aristocratic entertainment. A group of elegant men and women can be seen
descending the steps from the terrace, while others are setting out in a boat into a rocky, swirling
lake. The foaming waters and gnarled tree in the centre, reminiscent of Salvator Rosa, point to an
obvious contrast between the security of the group of spectators behind the balustrade and the
elemental forces of nature. There is, however, a theatrical unreality about the picture which
suggests that fashionable society is merely enjoying the thrill of exposing itself to mild dangers.

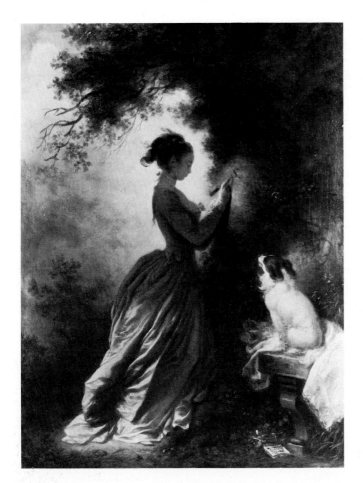

44 *The Souvenir* or *A Lady Carving her Name*
LONDON, Wallace Collection. c. 1775–80. Oil on canvas 25 × 19 cm. Signed on the edge of the bench: Fragonard.

Bought in 1865 by Lord Hertford for 35,000 francs at the Morny sale, the painting is related to a lost composition, recorded by Wildenstein (cat. no. 389) and entitled variously *A Lady Carving her Name* or *Angelica Writing the Name of Medor on a Tree* or *Fair Julia*. *The Souvenir* shows Fragonard at his most wistful and poetic, a mood which Corot later recaptured in works like the *Souvenir de Mortefontaine*.

45 *Portrait of Marguerite Gérard*
BESANÇON, Musée des Beaux-Arts. Bistre wash on charcoal sketch, white paper 18·6 × 13 cm.

Probably drawn in 1778. Collections: P. A. Pâris; Bibliothèque Municipale de Besançon.

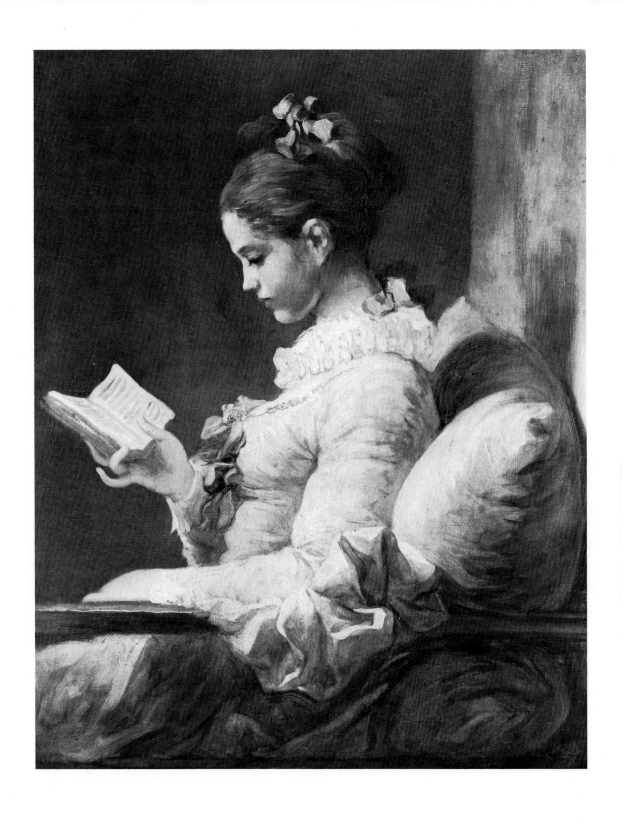

46 *Woman Reading a Book*

WASHINGTON, National Gallery of Art (Jules S. Bache collection). c. 1775. Oil on canvas 82 × 65 cm.

The theme of women reading was a favourite one with Fragonard. This painting, mentioned in the 1776 du Barry sale, shows him to have been as much at ease with women in studious moods as with erotic subjects. The yellows and ochres highlighted by the white ruff and the beautifully modelled face in pure profile make this a most appealing work. Its quiet, contemplative aspect was admired by the Impressionists, especially Renoir.

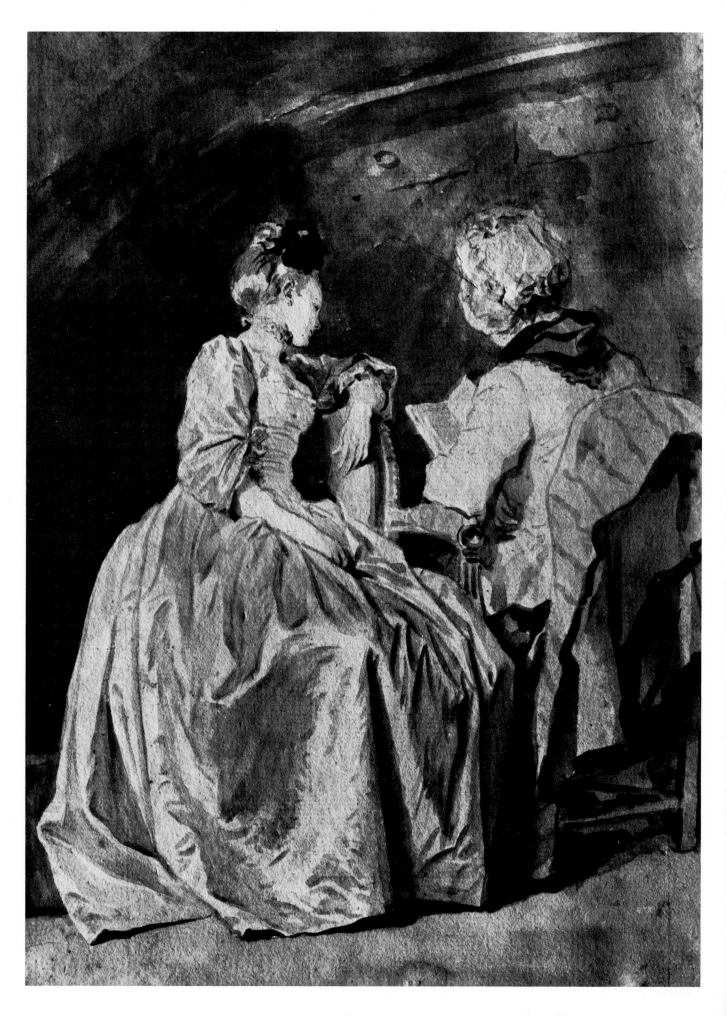

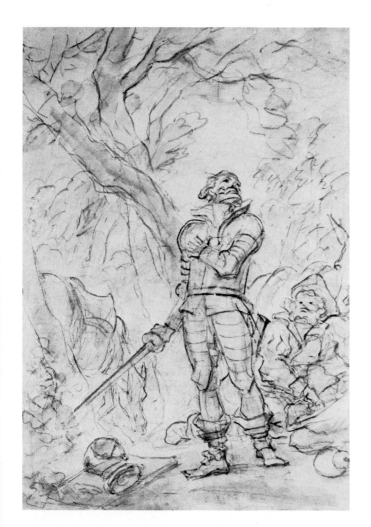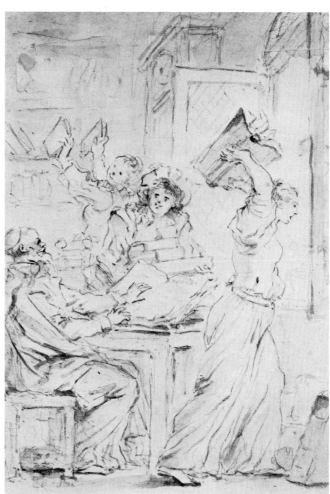

48 *Drawings for 'Don Quixote'*

These drawings, which have never been properly studied, were to be a great source of inspiration to Daumier. The projected edition of *Don Quixote* was never published; nineteen of the drawings were formerly in the collection of the Baron Vivant Denon.

(left)
a *Don Quixote Standing with Drawn Sword*
LONDON, British Museum. Chalk and wash 41·6 × 28·2 cm.

Sancho Panza is crouching behind.

(right)
b *The Priest Ordering the Destruction of Don Quixote's Books*
LONDON, British Museum. Chalk and wash 41·6 × 28·2 cm.

(opposite)
47 *The Reader*
PARIS, Musée du Louvre, Cabinet des Dessins. Pencil drawing on sepia wash 28·2 × 20·7 cm.

The Goncourts wrote of this drawing that 'Never did Fragonard create a woman out of so little. She stands out entirely clear, soft-limbed, almost transparent against the firm dark ground of the drawing. . . .'

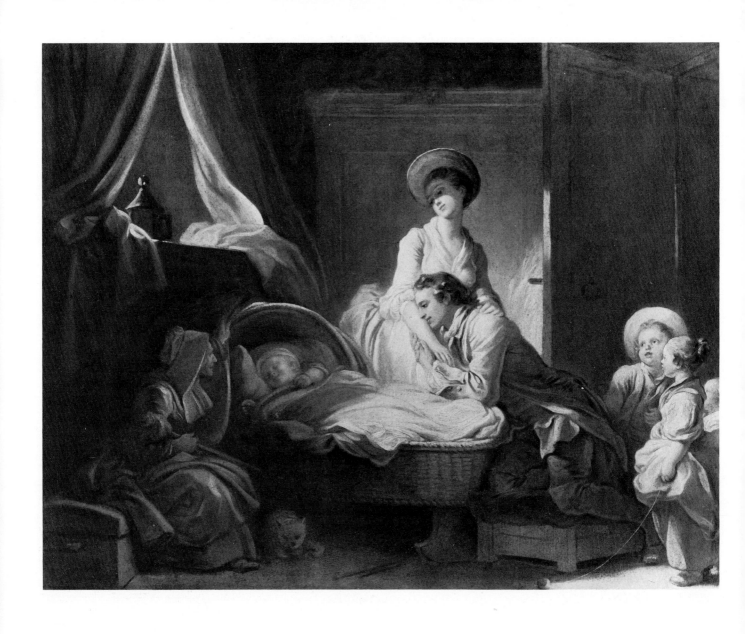

49 *A Visit to the Nurse*
WASHINGTON, National Gallery of Art (Samuel H. Kress collection). c. 1778. Oil on canvas
90 × 70 cm.

Mentioned in the Leroy de Senneville sale (1784) and sold again at the Constantin sale in 1816 for
seven francs, the painting is the subject of a preparatory sketch in a private collection in
Switzerland. The theme of the happy family recurs frequently in the artist's middle years. A young
husband and wife, with their two small children, have come to visit their new-born child at the
foster-mother's house. With this kind of domestic interior scene Fragonard came close to Greuze,
The Village Bride, for instance, while remaining entirely without the latter's moralizing overtones.
The mother is still the mondaine young coquette, not very different from the girl in *The Swing*
(Wallace Collection). Until the late eighteenth century it was still the practice among middle- and
upper-class families to farm out their children to foster-mothers, and it was only when the lessons
of Rousseau's *Emile* (1762) began to take effect that breast-feeding became fashionable again.

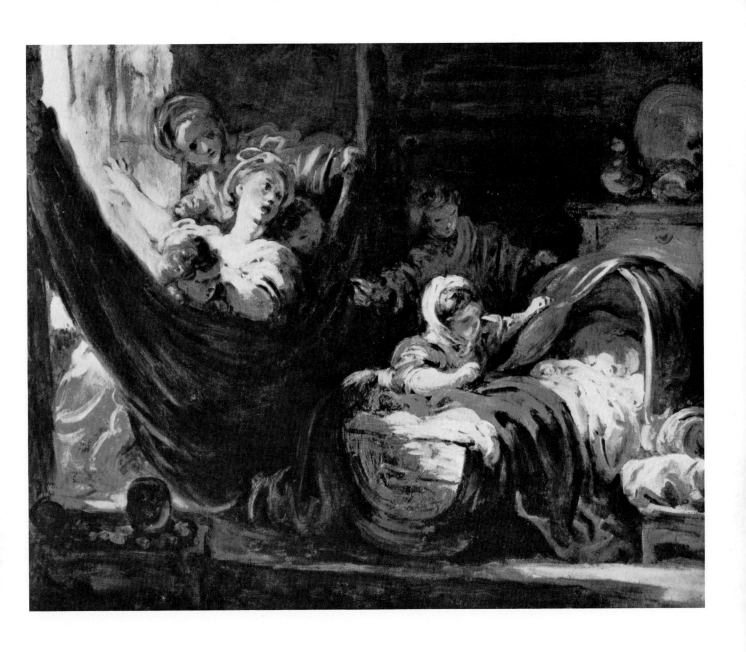

50 *The Cradle*
AMIENS, Musée de Picardie. c. 1777–79. Oil on canvas 46 × 55 cm.

Left to the Musée de Picardie by the Lavalard brothers in 1894, this picture is one of numerous versions painted by Fragonard on the theme of the cradle or the happy family, all of them closely related. L. Réau suggests that their common source is the novel *Miss Sara Th . . .* (1765) by J. F. de Saint-Lambert, well-known in his day as a pastoral poet. The theory seems plausible for the novel contains a scene in which a young farmer and his wife go to look at their fifth child in a cot, followed by their four others, the same number which can be seen in Fragonard's painting. *The Cradle* may also have been an attempt to rival Greuze on his own ground of domestic virtue and conjugal happiness.

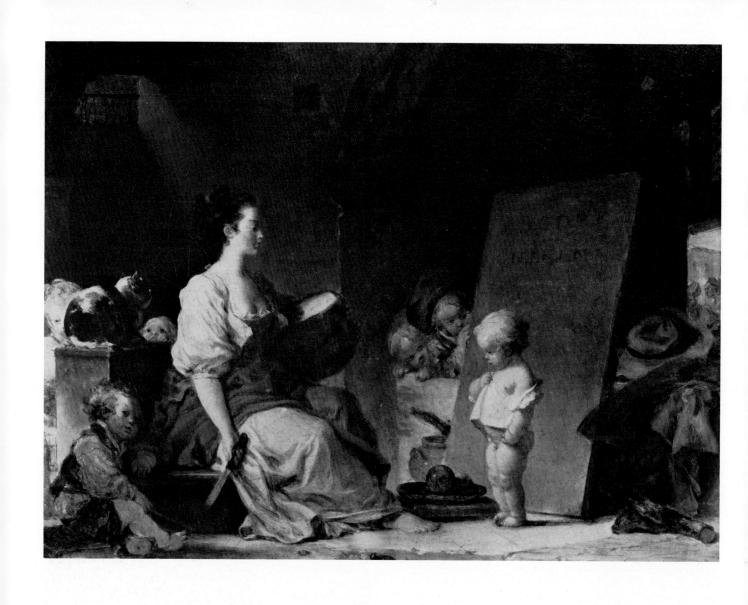

51 *The Schoolmistress*

LONDON, Wallace Collection. after 1780. Oil on canvas 28 × 37 cm. Signed on the blackboard after the letters of the alphabet: Fragonard.

The education of children was a favourite subject with Fragonard in his early forties, and this picture is related to a number of similar compositions, such as *The Little Preacher* (collection of A. Veil-Picard), *Say Please* (lost, but engraved in 1783) and *Education Does All* (Plate 52). The little boy is thought to be Fragonard's son Alexandre, who re-appeared almost identical in *The Reading Lesson* (Wildenstein, cat. no. 165). The setting for this humble village school seems to be the crypt of a disused Romanesque church, perhaps in Provence.

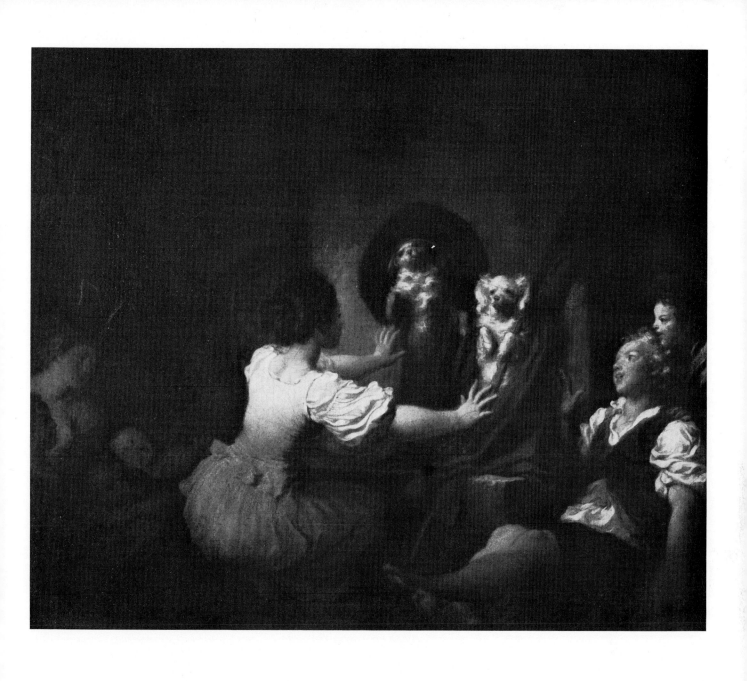

52 *Education Does All*

SÃO PAULO, Museum of Art. c. 1777–79. Oil on canvas 54 × 66 cm.

Engraved by N. de Launay as a pendant to *The Little Preacher*, this picture is a charming, if slightly sentimentalized version of *The Schoolmistress*.

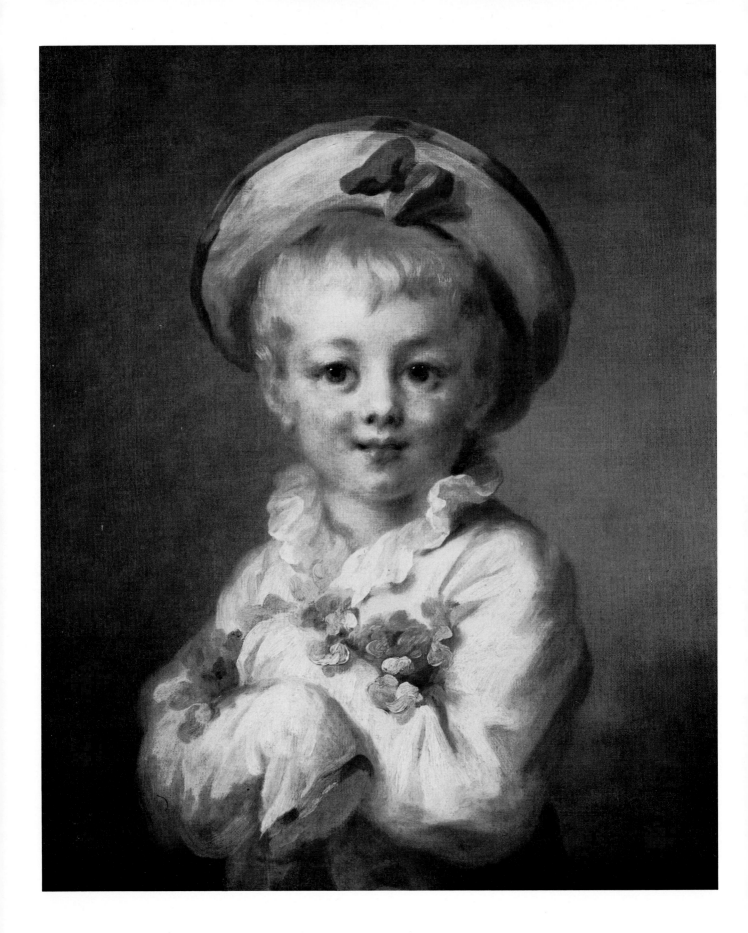

53 *Boy Dressed as Pierrot*
LONDON, Wallace Collection. After 1785. Oil on canvas 60 × 50 cm.

In the Cope sale of 8 June 1872, where it was catalogued as by Boucher, this portrait was bought at Christie's for Sir Richard Wallace. The extreme transparency of the surface of this picture curiously anticipates Manet.

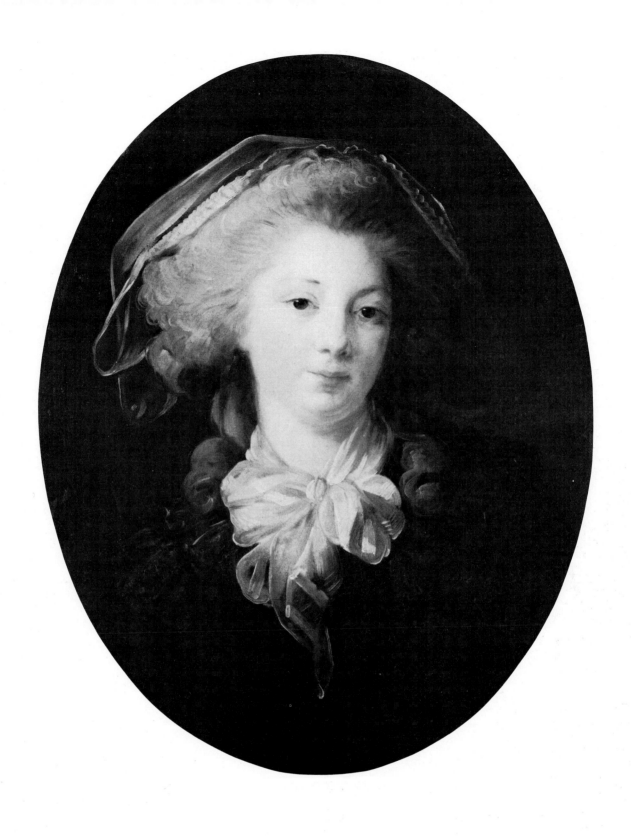

54 *Portrait of Madame Bergeret de Norinval*
PARIS, Musée Cognacq-Jay. c. 1780–89. Oil on canvas 60 × 50 cm.

This portrait is only attributed to Fragonard, but there can be no doubt about its superb quality.
The handling of the paint is exceptionally light and delicate, and the woman's veil consists of no
more than a gauzy white outline. The sitter's identity is uncertain. She may be a Mme. de
Norenval, reader to Queen Marie Antoinette, or else Mme. Bergeret de Norinval, wife of Adelaïde-
Etienne Bergeret, the nephew of Bergeret de Grancourt.

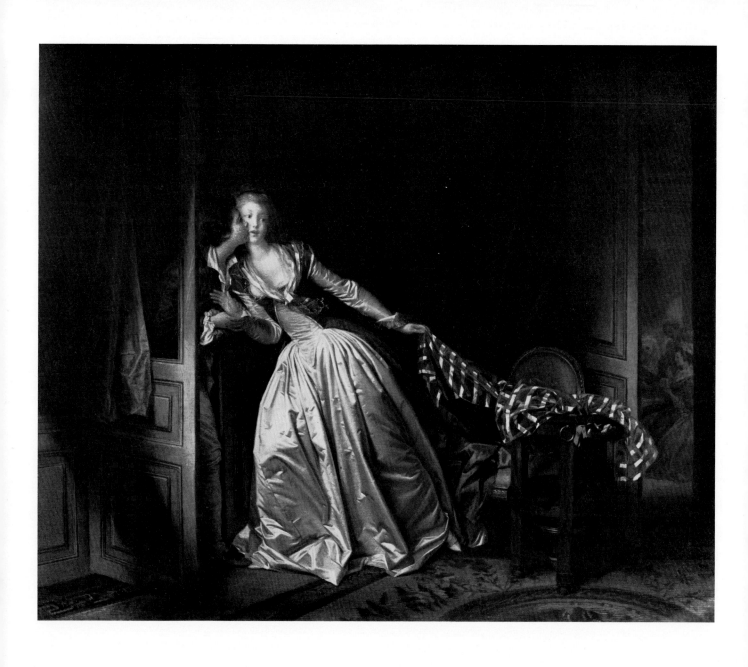

55 *The Stolen Kiss*
LENINGRAD, Hermitage Museum. c. 1786–89. Oil on canvas 45 × 55 cm.

The Stolen Kiss belonged to Stanislas Poniatowski, the last King of Poland, and was bought by
Tsar Nicholas II of Russia. It was transferred to the Hermitage in 1895. An engraving by
N. F. Regnault was published in the *Mercure de France* in 1788. The attribution to Fragonard is not
universally accepted; some see in this picture the hand of Marguerite Gérard. Others have pointed
out its affinity with the domestic scenes of Léopold Boilly. Several of Fragonard's late works,
including *The Bolt*, have the same curiously elongated forms, which may be a sign of his style
changing with the times; the sobriety of execution, the buff colours and dark green of the
background are unusual in Fragonard.

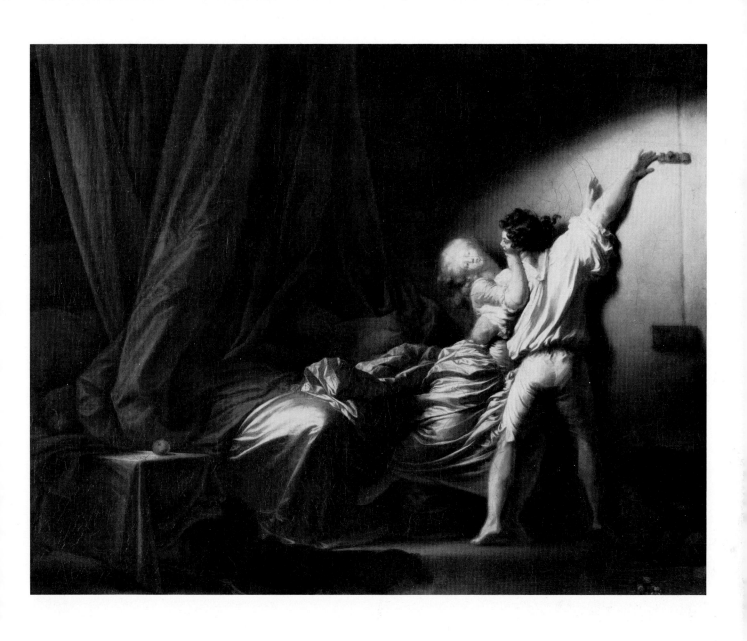

56 *The Bolt*
PARIS, Musée du Louvre. c. 1780. Oil on canvas 73 × 92 cm.

Originally in the collection of the marquis de Véri, *The Bolt* was acquired by the Louvre in 1972.
There is another, sketchier version in the New York collection of the baroness von Cramm, but the
Louvre painting is almost certainly the original from which Blot made his engraving of 1784. The
presence of the apple on the table has been interpreted, perhaps over-ingeniously, as a symbol of
the Fall, but there is little doubt about what is really happening in this picture. This is a
straightforward seduction scene, treated in the rather lurid manner of an erotic novel. *The Bolt*
suggests that, towards the end of his career, Fragonard turned away from the careless rapid strokes
of his earlier style in favour of a more highly finished, enamelled surface.

57 *Drawings for La Fontaine*

Fragonard probably executed five series of drawings for La Fontaine's *Contes* which were never published. In 1795 an edition by Didot was inaugurated, in collaboration with A. de Saint-Aubin and Tillard, but the project was interrupted by the Revolution.

(*left*)
a *Le Paysan et son Seigneur*
BESANÇON, Musée des Beaux-Arts. Pen and ink on bistre wash 19·4 × 13·8 cm.

Collections: P. A. Pâris; Bibliothèque Municipale de Besançon.

(*right*)
b *Les Cordeliers de Catalogne*
BESANÇON, Musée des Beaux-Arts. Pen and ink on bistre wash 20·2 × 14·1 cm.

Collections: P. A. Pâris; Bibliothèque Municipale de Besançon.

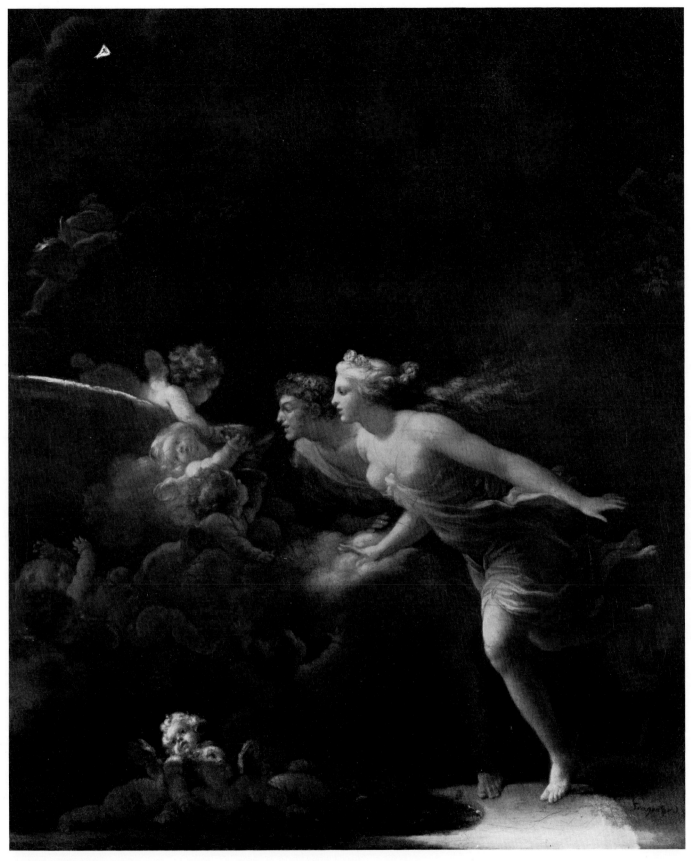

58 *The Fountain of Love*

LONDON, Wallace Collection. c. 1780–88. Oil on canvas 64 × 56 cm. Signed at the bottom on the right: Fragonard.

Numerous copies exist of this work, which was engraved by N. F. Regnault as a pendant to *The Dream of Love* (Paris, Louvre) in 1785. The two figures are drawn as if in a vortex to the fountain, the source of love, the motive force in so much of Fragonard's work. The allegorical treatment of the theme and strange, rhythmical figures are more in the spirit of Prudhon and even Fuseli than the Rococo.

Bibliography

Fragonard's life and work:

Ananoff, A., *L'Oeuvre dessiné de Fragonard*, 3 vols. Paris, 1961–68.

Ananoff, A., 'Différents séries de dessins exécutés par Fragonard pour les Contes de La Fontaine', *Bulletin de la Société de l'Histoire de l'Art Français*, 1960.

Biebel, F. M., 'Fragonard et Madame du Barry', *Gazette des Beaux-Arts*, 1960.

Fragonard. Drawings for Ariosto (with essays by E. Mongan, P. Hofer and J. Seznec). London, 1946.

Guimbaud, L., *Saint-Non et Fragonard*. Paris, 1928.

Portalis, Baron R., *Honoré Fragonard, sa vie et son oeuvre*. Paris, 1889.

Réau, L., *Fragonard, sa vie et son oeuvre*. Brussels, 1956.

Thuillier, J., *Fragonard*. Geneva, 1967.

Wildenstein, G., *The Paintings of Fragonard*. London, 1960.

Wildenstein, G., 'La Fête de Saint-Cloud et Fragonard', *Gazette des Beaux-Arts*, 1960.

Wilhelm, J., 'Fragonard as a Painter of Realistic Landscapes', *Art Quarterly*, 1948.

General material:

Bachaumont, L. P. de, *Mémoires secrets*. London edition, 1777.

Bergeret de Grancourt, J. O., *Voyage d'Italie 1773–74, avec les dessins de Fragonard* (ed. J. Wilhelm). Paris, 1948.

Besançon: Inventaire général des dessins des Musées de Province. Collection Pierre-Adrien Pâris (ed. M. L. Cornillot). Paris, 1957.

De Brosses, C., *Lettres familières écrites d'Italie en 1739 et 1740*. Paris, 1869.

Diderot, D., *Salons* (eds. J. Adhémar and J. Seznec). Oxford, 1957–67.

Florisoone, M., *Le Dix-huitième siècle*. Paris, 1948.

France in the Eighteenth Century (catalogue of the exhibition at the Royal Academy of Arts). London, 1968.

Goncourt, E. and J., *L'Art du dix-huitième siècle*. Paris, 1859–75.

Levey, M. and Kalnein, Graf W., *Art and Architecture of the Eighteenth Century in France*. Harmondsworth, 1972.

Mercier, L. S., *Tableau de Paris*. 1781.

Mornet, D., *Le Sentiment de la nature en France au dix-huitième siècle*. Paris, 1907.

Portalis, Baron R., 'La Collection Walferdin et ses Fragonard', *Gazette des Beaux-Arts*, 1880.

Seznec, J., 'Don Quixote and his French Illustrators', *Gazette des Beaux-Arts*, 1948.

Wildenstein, G., 'L'Abbé de Saint-Non artiste et mécène', *Gazette des Beaux-Arts*, 1959.

Wildenstein, G., 'Un Amateur de Boucher et de Fragonard, Jacques-Onésyme Bergeret (1715–85)', *Gazette des Beaux-Arts*, 1961.